PHOTOGRAPHING
PEOPLE LIKE A PRO

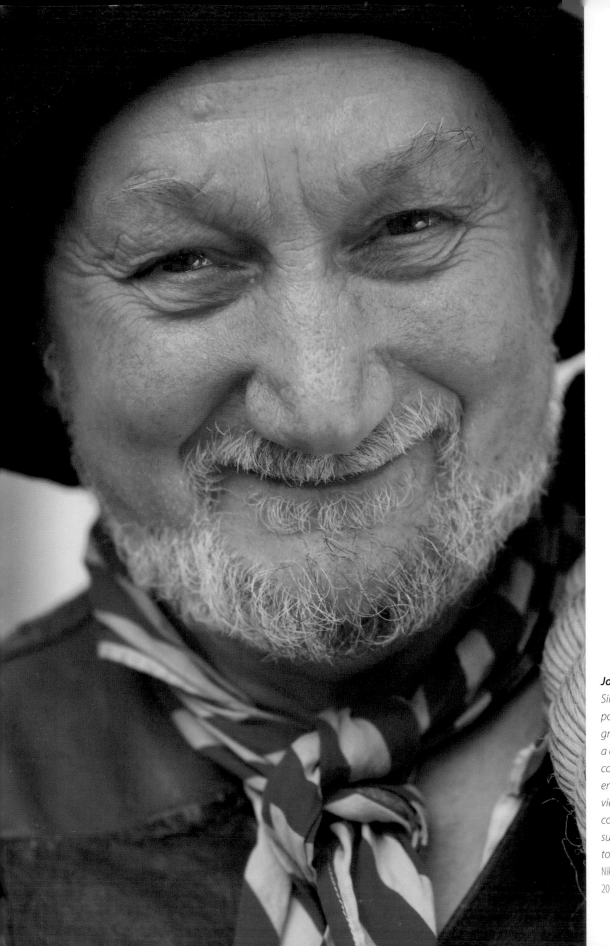

Joss

Simple character portraits make for great images. With a close crop, eye contact and an endearing smile, the viewer immediately connects with the subject and is able to identify with him. Nikon DX, 85mm f/1.8 lens, 200 ISO, 1/640sec at f/3.2.

PHOTOGRAPHING PEOPLE LIKE A PRO

A guide to digital portrait photography **Rod Edwards**

David and Charles

To my mum, dad and sister for their never-ending faith and support, and to my kochanie *Eva for her kindness and her beauty. A big thanks to you all …*

A DAVID & CHARLES BOOK
Copyright © David & Charles Limited 2008

David & Charles is an F+W Publications Inc. company
4700 East Galbraith Road
Cincinnati, OH 45236

First published in the UK in 2008
First published in the US in 2008

Text and photography © Rod Edwards, 2008

Rod Edwards has asserted his right to be identified
as author of this work in accordance with the
Copyright, Designs and Patents Act, 1988.

A catalogue record for this book is available from
the British Library.

ISBN-13: 978-0-7153-2823-1 hardback
ISBN-10: 0-7153-2823-9 hardback

ISBN-13: 978-0-7153-2824-8 paperback
ISBN-10: 0-7153-2824-7 paperback

Printed in Singapore by KHL
for David & Charles
Brunel House, Newton Abbot, Devon

Commissioning Editor: Neil Baber
Editorial Manager: Emily Pitcher
Assistant Editor: Sarah Wedlake
Art Editor: Sarah Clark
Project Editor: Ame Verso
Proofreader: Nicola Hodgson
Indexer: Lisa Footitt
Production Controller: Beverley Richardson

Visit our website at www.davidandcharles.co.uk

David & Charles books are available from all good
bookshops; alternatively you can contact our Orderline
on 0870 9908222 or write to us at FREEPOST EX2 110,
D&C Direct, Newton Abbot, TQ12 4ZZ (no stamp required
UK only); US customers call 800-289-0963 and Canadian
customers call 800-840-5220.

CONTENTS

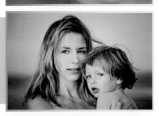

INTRODUCTION

When I sat down to start writing this book I asked myself, exactly what is it that makes a good portrait photograph? Anyone can shoot a portrait, even with very basic equipment, so what is it that makes one picture better than another? These are very difficult questions to answer as there are no definitive responses, but there are various ways in which a photographer can capture a person's unique nature and create an image to be proud of. This book is not intended to show advanced and complicated studio or location lighting techniques, but it will demonstrate how you can achieve professional results in a number of simple and easy-to-master ways.

The Oxford English Dictionary defines a portrait as, 'a likeness of a person, especially one showing the face, that is created by a painter or photographer, for example.' However, a portrait (from the French verb *portraire*, to portray) should transcend a mere physical likeness. It should also reveal personality without the need for words. A portrait is about conveying mood – be it happiness, sadness, strength or vulnerability – but it must also create an emotional response in its viewers, so that they ask themselves more about the sitter: who is this person, what is their story, and what were they thinking about when the photo was taken?

No two people are the same. We are all individuals, each with our own unique character and strengths and weaknesses. Even identical twins are different – they may look the same, but the similarity is only skin-deep. This individuality is what needs to be captured in a portrait; the true expression of self is what differentiates a good image from a bad one.

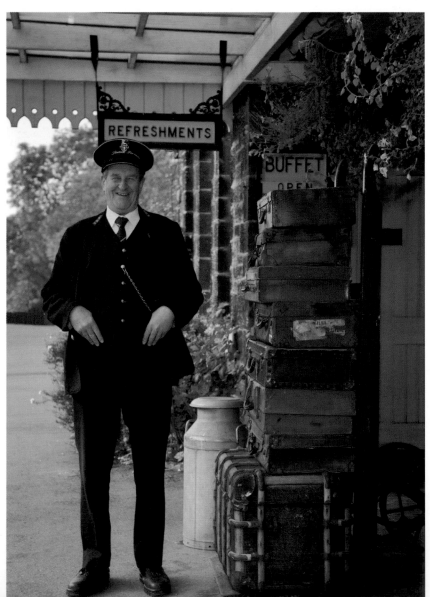

Station Master
A good portrait will capture the inner personality of an individual as well as their physical likeness. To be able to depict this you will need good people skills as well as familiarity with your equipment.
Canon, 24–105mm f/4 zoom lens at 65mm, 100 ISO, 1/60sec at f/5.6.

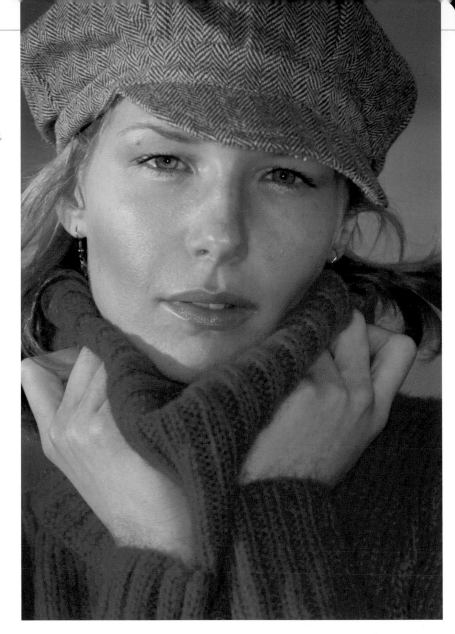

Eva
*By shooting people around sunrise and
sunset, you will be able to make the most
of the soft, warm natural light, which will
result in truly atmospheric images.*
Nikon DX, 70–200mm f/2.8 zoom lens at 200mm, 100 ISO,
1/250sec at f/4.

LIGHTING

The quality of light in a portrait (indeed in any photographic image) is very important and should not be overlooked. The best landscape photographers have learned that the ideal times to shoot great landscape images are during the so-called 'magic hours' around sunrise and sunset, and this can also be true of good people pictures. The changing moods of natural light can be used as a tool to convey your message. In a similar manner to an artist choosing his brushes and colours, the photographer can select the effect the quality of light has on the contours of the subject's face – quite literally painting with light.

Professional photographers react to different lighting conditions in a conscious way, but for someone who knows little about light and its characteristics, this is more often a subconscious reaction. However, if you can learn to read the way light plays upon a subject and begin to recognize how its changing qualities affect your emotional responses, you will soon become a master of light both in the studio and on location.

Daylight is perhaps the most beautiful and most emulated of all types of light. Studio photographers the world over spend a great deal of time, effort and money trying to recreate the elusive nature of this light on demand, so that they can work when the weather is inclement and in a more controllable environment. But the best thing about natural light is that it is cheap! With the aid of some camera and computer techniques, daylight can be manipulated and controlled in an infinite number of ways to produce wonderful images. Yes, it can be simulated, but unless you want to spend a small fortune on expensive equipment, studio space and running costs, you should not forget the flexibility and convenience of humble daylight.

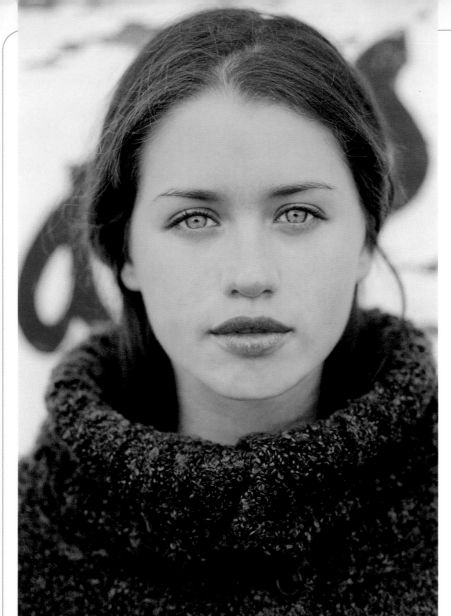

Lea

You don't need expensive lighting equipment to shoot eye-catching people images. Just natural daylight with its wide, soft palette of colour, contrast and tone will often be enough to capture arresting shots.
Nikon, 85mm f/1.8 lens, Fuji Reala 100 ASA film rated at 64 ASA, 1/500sec at f/4.

That being said, studio lighting is also an important part of the photographer's arsenal. It is reliable, consistent and adaptable – but to get the best from it you need to know your equipment. Take the time to try different types of reflectors and attachments and learn the subtle differences between them, as it's only by understanding this that you will be able to fully master them. Without a great deal of experience, studio equipment can produce rather humdrum results. Too many high-street studio photographers just attach a large, plain softbox or umbrella and blast away at their sitter, producing flat, uninspiring images that are flooded with too much light. Remember that shadows also play a vital part in producing striking photographs that will captivate the viewer – they are the silences in a musical score; they are the words in a poem that are left unsaid; when light is the yin, shadows are the yang.

COMPOSITION

Equally as important as light and shadow is good composition. This is an element that is often disregarded by amateurs who rush to take snaps, but it is essential to any good photograph, portrait or otherwise. Despite there being some readily accepted compositional rules, in reality there is no right or wrong way to compose a picture. The intricacies of good design cannot be taught in a few sentences, but as you gain confidence you will begin to appreciate well-balanced images, and use the basic rules to your advantage. At times, you may want to break away from these conventions to produce a more daring image, but this will come with experience and an objective analysis of your own work and that of other photographers. Above all, what you choose to say should come from within, so rely on your instincts and your personal vision to develop your own creative style.

CAPTURING CHARACTER

When shooting a portrait, you are trying to record in just two dimensions the three-dimensional subject in front of you. But you also want to try to capture a fourth dimension – their personality. To do this, you need to ask yourself what you want to say about the sitter. Do you want to capture the beauty and femininity of a woman, portray a man's strength and masculinity, or reveal the innocence and excitement of a child? Whatever it is you want to convey, as a photographer you must make observations and judgments about your subject – the way they dress, their mannerisms, expressions, facial features, body language and physiognomy. Learn to read and interpret these signals and you will find yourself in a powerful position to take good portraits.

Finally, and perhaps most importantly, comes your own personality. It's not just technical ability but also people skills that make a good portrait photographer. Everyone will have their own way of approaching portrait sessions. Some will use their communication skills to help the subject to relax; others might find the sound of silence brings out the personality of their sitter. Some photographers prefer their model to smile or laugh, while others favour a more thoughtful, pensive expression to try to capture the inner nature of their subject.

Sometimes your best image will be the first frame that you take, and at other times it will be the last photo of the afternoon when you finally see that you've managed to get your shot. With practice and patience, all these abilities will become intuitive and you'll stop thinking about your camera and just start taking fantastic images.

So, how do you go about capturing this elusive great portrait? The aim of this book is to give you a large number of professional tips that have taken me years of practice, many hours of frustration and many fractions of seconds of exposures to learn. Read on and you'll learn how to photograph people like a pro …

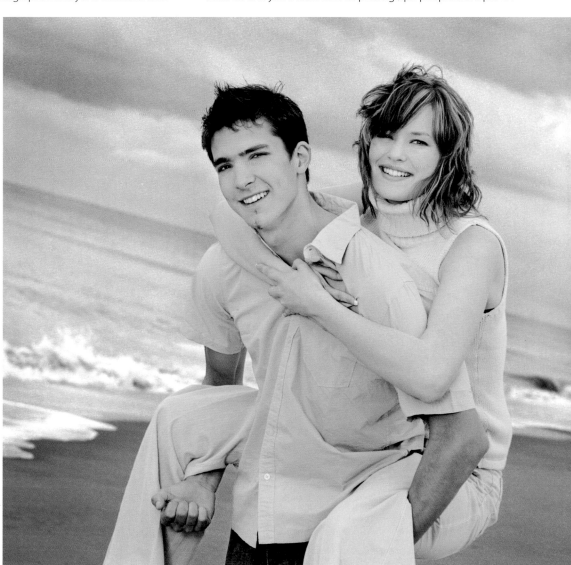

Robert and Grace
The best portraits communicate the emotions of the subjects in them. Always aim to convey the mood of your sitters and capture that particular moment in time.
Mamiya, 150mm f/3.5 lens, Kodak T-Max 400 ASA film, 1/250sec at f/8.

CAMERAS

It has never been easier to take great people pictures than it is now. A few years ago, when most pros used slow-speed transparency film, nailing that elusive shot was something of a black art. You had to rely upon expensive equipment, a wealth of experience and a little bit of good luck and judgment thrown in. It wasn't always possible to assess the effect of studio flash upon your sitter and even less so to judge whether you had perfectly exposed the frame. However, with the advent and affordability of good-quality digital cameras, this is now within easy reach, as images can be instantly checked on the LCD screen.

Today's digital cameras also offer many other benefits over their film counterparts. Features such as fast autofocus, automated exposure systems, built-in flash, sophisticated program modes, vibration reduction and high capture rates all make for a much less bumpy ride on the road to taking fine portrait photographs. Right now, we're at a time when digital can completely replace 35mm film and is able to stand up and be counted. Within minutes of releasing the shutter, the images can be downloaded to your computer, retouched and printed out, ready for the family album or for sharing via the Internet with your friends all over the world. Digital photography has now come of age and this book will teach you how to make the most of it.

THE DIGITAL SINGLE LENS REFLEX (SLR) CAMERA

The most important tool for a portrait photographer is a digital SLR camera. If you want almost unlimited flexibility with settings, perspectives and depth of field (area of focus) there is no real alternative. While it is possible to take good portraits with a simple compact camera, you will often find yourself fighting against the camera's full automation and this will limit both your creative freedom and, ultimately, the success of your images.

With a digital SLR and a small selection of reasonably priced lenses, you have far more control over exactly how the final images will look when they come straight from the camera. You can use different lenses to produce a variety of creative effects, such as powerful perspective distortion with a super wide-angle lens, or strong compression of features and a smoothly blurred background with longer lenses. With a digital SLR, you also have the ability to choose exactly the effect you want and how the final image will appear, by selecting the right lens for the job as well as the desired aperture, shutter speed and exposure settings. Digital SLRs also allow you to look through the actual taking lens, decide what you want to focus on and see exactly what you are photographing, whereas with a digital compact, you may get a nasty surprise such as improper focus or parallax error, where the lens sees something different to what you saw through the viewfinder. With so many lenses, accessories and so much versatility, a digital SLR is a real photographer's camera, which, with a little skill and knowledge, will deliver high-quality images that will help realize your photographic vision.

Digital SLRs are also great for communicating ideas and experimenting with new digital tricks and techniques. All of these benefits add to both the success of your creative workflow and the amount of fun you can have taking the photos in the first place.

Canon
The flagship of the current Canon digital SLR range is the 21MP EOS-1 Ds Mark III. It is reliable and reassuringly expensive, as it is built to cope with the rigours a professional photographer will put it through on a daily basis.

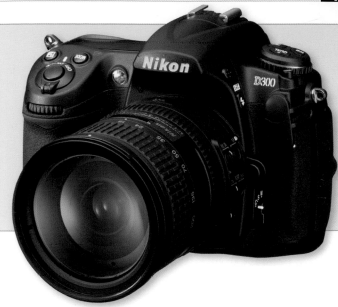

Nikon
The Nikon D300 is a 'prosumer' camera that has over 12MP and bridges the gap between pro and consumer digital SLRs.

RESOLUTION

Many photographers get over-excited about pixel counts, but you don't have to spend a fortune on high-end professional-specification cameras to be able to achieve impressive results. With a good-quality lens, digital cameras with anything over 8–10 megapixels (MP) should provide good enough quality to print on the cover of *Vogue*, or any other glossy magazine for that matter. Pro-spec cameras do have higher resolution (more megapixels) and are built to withstand the daily knocks they'll get from a busy working pro, but this is the only major difference between these and more modestly priced digital cameras. The higher the pixel count, the greater the image should be able to withstand enlarging – even an 8–10MP camera can print up to A4 (29.7 x 21cm/11¾ x 8¼in) at 300dpi (dots per inch) and when will you really want to print a portrait much bigger than that? Even if you do, you'll probably find the softness of interpolation will flatter the skin textures of your subject more

than a super-sharp high-resolution pro-spec camera, which will emphasize any imperfections. If you are intending to sell your work and absolute resolution is paramount, then a pro-spec model will be more suitable, but for day-to-day photographs a modest and inexpensive digital SLR will be more than adequate.

MAKES AND MODELS

All of the mainstream digital camera manufacturers produce great pieces of kit. My personal preference is for Nikon and Canon digital SLRs, as they have proved to be the market leaders and continue to push the quality and capability of their products with every new model they introduce. Other manufacturers such as Olympus, Fuji and now Sony also produce excellent digital cameras. Whatever brand you choose, the quality that's available today would have been in the realms of hugely expensive pro digital cameras just a few years ago.

Admittedly, it's often hard keeping pace with the speed of advancing technology, and new cameras become out of date quite quickly, but don't be taken in by the marketing ploys of

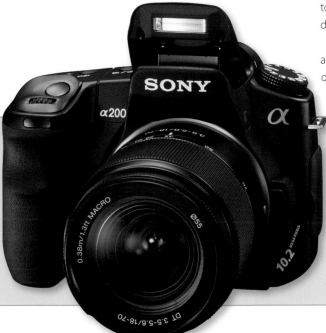

Sony
Sony has also entered the prosumer digital SLR market with fine-quality and very affordable digital cameras. This a200 boasts 10MP and comes with an 18–70mm lens.

the manufacturers who try to entice you with shiny new bits of equipment that are sure to guarantee you better pictures and your place in digital Valhalla. Even with an entry-level digital SLR, some imagination and the skills that this book will give you, you'll find yourself making great images in next to no time. It really is a case of 'it's not what you've got, it's what you do with it that counts.' For this reason, in the captions to the photographs in this book I've resisted the temptation of stating which make and model of camera was used – it really isn't important. Just enjoy whichever camera you have, become familiar with how it works and stop suffering from equipment angst.

SENSOR SIZE

Next we come to the full-frame or cropped sensor debate for digital portraits. Some photographers swear by the full-frame sensor as it has more restrictive depth of field, but this obviously has its pros and cons. On the plus side, shallow depth of field can be ideal for portraits when you wish to throw backgrounds out of focus, but on the other hand, cropped sensors can achieve similar depth of field with a slightly longer lens while standing further back. Add to this the fact that you sometimes may not even want to shoot at small apertures for limited focus and you can see that the differences are largely academic. Cropped sensor cameras and lenses are capable of rendering excellent results at very reasonable prices, so don't spend your time fretting over equipment – spend your time taking pictures and polishing up your photographic skills. The truth is that most modern cameras are perfect for taking great images and the most important piece of kit you can bring with you on a shoot is your imagination. It's this that will distinguish your work from others' and make your people images stand out from the crowd.

One final point: since lens, aperture and shutter speed are such an integral part of the process of taking photos, I have supplied the technical information to many of the images in this book. This will hopefully help to illustrate the different effects that these camera and lens settings have on the final image.

Tori and Richard
Whatever camera you are shooting with, the real success of your portrait images is less about your camera resolution and more about your people skills, creativity and imagination.
Mamiya, 150mm leaf shutter f/3.5 lens, Fuji Reala 100 ASA film rated at 64 ASA, 1/500sec at f/5.6.

Crop factors
This image shows the effective crop factors of various digital cameras. The picture was taken with an 85mm full-frame camera with zero crop factor. The boxes show the Canon 1.3x, the Nikon DX 1.5x and the Canon 1.6x field of view using the same effective focal length lens.

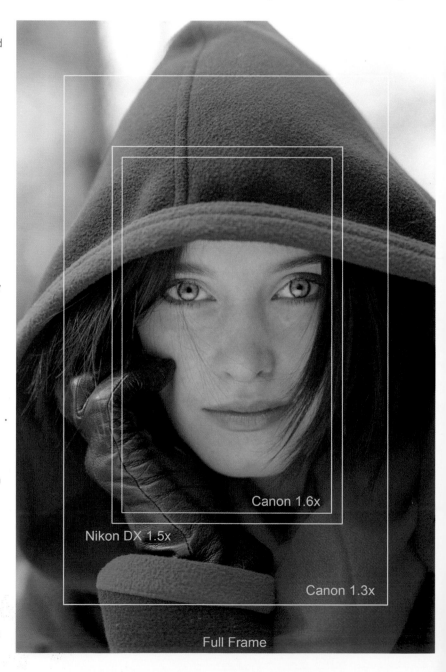

Canon 1.6x

Nikon DX 1.5x

Canon 1.3x

Full Frame

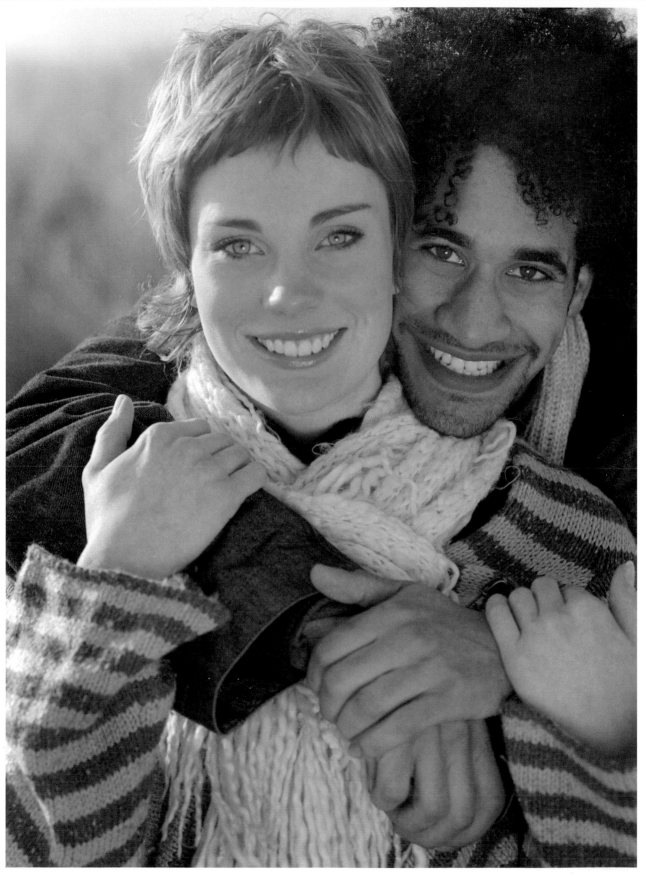

LENSES

When it comes to selecting lenses for photographing people, the good news is that there are no right or wrong lenses, just the best lens for the job in hand. Effectively, this means that there are no hard-and-fast rules for portrait photography, but it's important to choose the correct lens for the effect that you are trying to achieve. In my work, I use lenses ranging from 16mm through to 300mm on a full-frame 35mm digital camera (approx. 10.5mm to 200mm on a 1.5x cropped image sensor) depending on the subject, the background, the circumstances and the perspective effect that I am aiming for in each shot.

WIDE-ANGLE AND SHORT LENSES

Lenses ranging from 16–35mm (approx. 10.5–24mm on a cropped image sensor) are perfect for dramatic perspectives and environmental portraits, when it's important to include some of the background.

Photojournalists frequently use lenses in this focal range to depict their subject in a dramatic way, while also including some of the surroundings, as it all helps to tell the story and communicate what the photographer is trying to say. Wide-angle lenses also have an inherently large depth of field, meaning a great deal can be kept in focus, and the shorter focal length allows for slower shutter speeds without the risk of camera shake.

As wide-angle lenses exaggerate perspective, they can be a very powerful way of creating images with an unusual feel or sometimes even a surreal quality when reality isn't necessarily a top priority.

Due to the optical characteristics of wide-angle lenses, they tend not to provide a very flattering perspective for more traditional-style portraits. Since it's often necessary to move in close to your subject in order to fill the frame, the resulting images are susceptible to perspective distortion and facial features tend to become overemphasized. An individual with a large nose won't thank you for moving in close to them with a short lens, as their nose will look even bigger in the final image, and you'll soon find yourself struck off their Christmas card list. Unless this is the effect you're after, always use wide-angle lenses with some degree of caution.

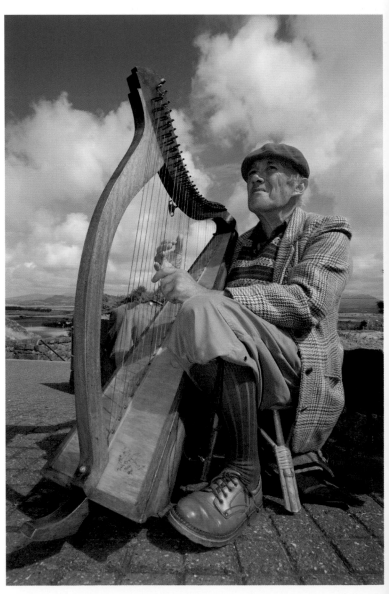

Bargoed
A wide-angle lens can be used to exaggerate perspective for dramatic effect. It is perfect for environmental portraits, such as this shot of a Welsh harpist.
Kodak, 17–35mm f/2.8 zoom lens at 19mm, 160 ISO, 1/125sec at f/13.

Sam
*Images shot on a standard lens of around 50mm produce a field
of view that largely approximates that of the human eye, and has
little perspective distortion.*
Canon, 50mm f/1.2 lens, 100 ISO, 1/400sec at f/5.6.

STANDARD LENSES

Lenses in the range of 35–75mm (approx. 24–50mm on a
cropped image sensor) are great for creating images with a far
more natural look than a wide-angle or a long telephoto lens
(see page 16). Standard lenses don't exaggerate perspective, nor
do they compress it, and the field of view they produce is very
similar to our own eyes – meaning that what you see through
the viewfinder is largely what you will get in the final image.

Lenses within this focal range, or standard 50mm lenses, are
frequently used by professional portrait photographers, as they
enable them to shoot full-length portraits without having to
be too far away. They also avoid the need to have an oversized
studio space, as you can stay close to your subject. Personally, I
love shooting with a standard 50mm lens as it allows me to work
quickly with no nasty surprises or distorted facial features.

SHORT TELEPHOTO LENSES

Lenses in the range of 75–135mm (approx. 50–90mm on a cropped image sensor) are in many ways considered to be the ideal length portrait lenses. They allow a reasonable distance between subject and photographer (without having to shout) and, due to the optical characteristics of telephoto lenses having shallower depth of field, they give you the ability to blur the background and concentrate the viewer's attention on the subject. Short telephoto lenses also allow you to close in to frame the head and shoulders and maintain a normal perspective without exaggerating facial features, thereby flattering the subject. Lenses in this focal range also tend to be reasonably light and quick to operate and this usually translates into better images.

I love using lenses within this focal range for many of my portraits, as they deliver pleasing results with few complications.

MID TO LONG TELEPHOTO LENSES

Finally, lenses in the range of 135–300mm (approx. 90–200mm on a cropped image sensor) can also be good for producing flattering portraits as they help to compress perspective. This is a very useful trick as it gives you the ability to shorten the appearance of a larger nose and works in the opposite way to the distortion provided by a shorter or wide-angle lens. Longer lenses are ideal for candid shots as they permit you to keep a good distance from your subject and hopefully take the picture unnoticed.

The optical characteristics of a longer lens also let you blur a distracting background without using very large apertures. A 300mm lens at f/5.6 for a head-and-shoulders composition will usually throw a distracting background nicely out of focus. However, when using longer lenses, remember to shoot at a fast enough shutter speed to avoid camera shake – image-stabilization and vibration-reduction telephoto lenses can be really useful here. If you haven't got this luxury, a good rule of thumb is to remember to shoot at a shutter speed whose reciprocal is as fast (or faster than) your lens's focal length. For example, when using a 300mm lens try and shoot at 1/300sec or faster to retain pin-sharp images. Also remember that when using zoom lenses you must shoot at the reciprocal of the longest focal length, not the length you are shooting at, so when using a 70–300mm zoom, always try and shoot at 1/300sec or faster and up-rate the ISO (or ASA if using film) if necessary.

Catherine
Short telephoto lenses in the range of 85–105mm are often known as portrait lenses as they provide a very pleasing perspective and limited depth of field.
Nikon, 85mm f/1.8 lens, Kodak T-Max 400 ASA film, 1/500sec at f/4.

ZOOMS VS PRIMES

Over recent years, the humble prime lens has become rather overshadowed by the convenience and low cost of standard zoom lenses. Admittedly, technical advances in optics have allowed modern zoom lenses to match and sometimes even exceed the quality of a fixed prime such as a DX 50mm or DX 85mm lens, but if you choose your lens wisely, you'll find a prime lens will really benefit the quality of your final images. Another important point to make about these lenses is that they're a real pleasure to work with.

Due to their simple design, prime lenses always come with super-fast maximum apertures such as f/1.2–f/2, meaning a lovely, bright viewfinder image compared to f/4–f/5.6, which is more common in standard zooms covering a similar focal length. Although you'll rarely use a prime lens at its maximum aperture

– as focus needs to be critical and depth of field is so shallow – you will find that if you close down a couple of stops to f/4 or smaller, your images will be so bitingly sharp that you'll need to handle them with leather gloves. Once again, unless you do have a real addiction to super-fast maximum apertures, you won't need to spend a great deal of cash on a good-quality prime. A 50mm or 85mm with a maximum aperture of f/1.8 will improve your photography so much that you'll wonder how you ever managed without one. Add to this the fact that many primes have circular aperture blades, which produce lovely, soft, out-of-focus backgrounds – an effect called 'bokeh'. The only drawback with using a prime lens is that instead of zooming to change the size of the subject in your frame you'll need to use your legs to move back and forth, but ultimately this will be a benefit to your waistline!

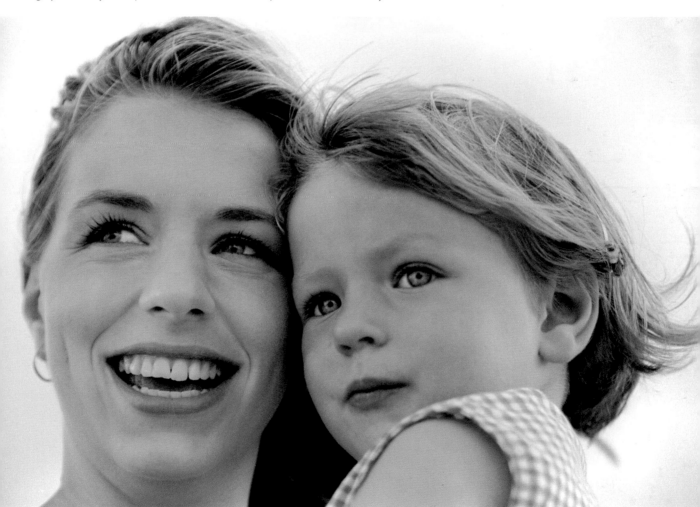

Jenny and Mackenzie
Mid to long telephoto lenses in the range of 135–300mm are great for compressing perspective, isolating your subject against a background and allowing you to remain at a comfortable distance.
Nikon, 70–300mm f/4–f/5.6 zoom lens at 300mm, Kodak T-Max 400 ASA film, 1/500sec at f/5.6.

LIGHTING AND ACCESSORIES

It's perfectly possible to take great people photographs with the absolute minimum of equipment, using just natural light. However, if you want more flexibility, consider investing in some relatively affordable lighting and some simple accessories. You don't have to spend a fortune to set up your own home studio and by doing so, you'll have the opportunity to shoot in all weathers, even when it's cold and dark outside. Alternatively, if you want to add an extra dimension to your location work, a list of really useful items follows … you'll soon begin to wonder how you ever managed without them.

IN THE STUDIO

Over the past few years, large studio lighting manufacturers such as Elinchrom and Bowens have decided to produce good-quality studio starter kits for less than the cost of a decent digital SLR. These kits are great to whet your appetite and to play around with until you decide the time has come to upgrade to a more advanced system. These home studio starter kits are fully compatible with the whole range of professional light-altering accessories including softboxes, umbrellas and reflectors.

A whole book could be written on studio lighting and accessories alone – indeed several have been – but here is a list of useful items that every home studio photographer should consider:

- **Softbox** – for softening the light to appear more like window light. These come in various shapes and sizes but a simple square one would be ideal – the bigger the better (within reason).
- **Umbrella** – for diffusing the light to resemble a direct soft light. This also includes shoot-through umbrellas and those with silver or gold interiors to change the intensity and colour of the light.
- **Flash head reflectors and attachments** – all with subtly different effects of light quality. To start with you may like to try a simple standard reflector that is not too wide and uncontrollable so as to flood your sitter – remember shadows are important too.
- **Barn doors/honeycombs, snoots and spots** – all have their own uses and different effects on light. If you do decide to play around with these, keep the set-up simple until you become more familiar with their effect.
- **A good light/flash meter** – if you're working indoors with studio flash equipment this is a must-have accessory. Many modern meters can measure both ambient light (i.e. daylight) as well as flash light and some can even measure the ratio of flash to daylight.
- **Backgrounds** – personally I dislike the backdrops that are so overused by high-street portrait studios. They are OK in certain circumstances though, and the plain-coloured ones can be used to great effect, but on the whole I like to use simple white, black or grey backdrops and chose to over- or under-light them depending on the desired effect.

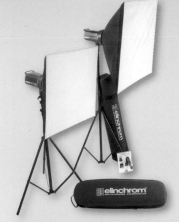

Elinchrom D-Lite 2
This flash kit is an affordable introduction to studio photography and is compatible with the whole range of Elinchrom lighting accessories.

Flashgun
The Canon 580EX II dedicated flashgun is a high-powered flash that slips into the on-camera hotshoe to provide a high-quality portable lighting solution.

Lastolite Tri-Grips and reflectors
Lastolite manufactures all kinds of lighting accessories that will help to improve your people photographs. The Tri-Grip range is similar to the standard reflector range, but can actually be held by the photographer while taking the picture.

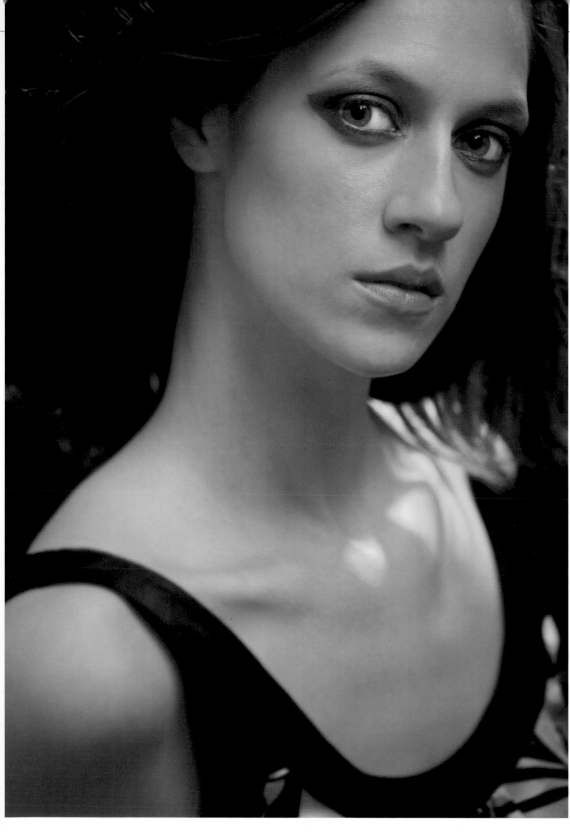

Michelle

A home studio can give you more control, flexibility and convenience than an outdoor location. This simple studio portrait
was taken using just one rear hair light and a softbox from the Elinchrom D-Lite 2 kit.
Canon, 70–200mm f/4 zoom lens at 135mm, 100 ISO, 1/250sec at f/4.

ON LOCATION

It is, of course, possible to take your home studio outdoors and shoot on location with a suitable portable power source, but this technique is cumbersome, risky and often requires several willing assistants. However, professional results can be achieved with the minimum amount of fuss and expense. Here are the items that you will find invaluable in your quest for shooting eye-catching people images outside the studio:

- **Portable flashgun** – strangely enough, flash can be really useful outside in full daylight and even more useful in harsh sunlight. So-called 'fill-flash' techniques can be a convenient way of filling in the shadows with a small blip of flash. This has the effect of lowering localized contrast on the sitter and means that skin textures are less pronounced, shadows are not as dark and you'll even create catchlights in your models' eyes. The built-in flash on many digital SLRs is sometimes sufficient for this technique though, which saves you having to carry extra kit – ideal, for example, when you are trying to shoot candid portraits in urban locations.
- **RingFlash adaptor** – this particular light modifier can produce really interesting professional fashion-style results at a very cheap price. Until a clever Czech photographer invented this item, to get a ringflash effect, you needed to buy a very expensive and powerful flash head that either plugged into the mains supply or ran off a heavy-duty battery pack.

However, this little device weighs only 500g (1lb) and simply attaches to your portable flashgun. It gives off a very soft light that is almost shadowless, as the flash is bounced around a collection of internal prisms before it is emitted in a ring of light around the lens.

- **Reflectors** – panel reflectors (as opposed to studio flash head reflectors) can be used to modify the quality of light both on location and in the studio. The most common ones are white, silver or gold in colour and they have the effect of bouncing light back in to the shadows and producing a generally more flattering look. I'm a big fan of Lastolite foldable reflectors and many of the images taken in this book would not have the same feel without them. Lastolite produces a whole range of different sized reflectors that can simply be twisted to fold them away into a very light and portable bag. You can of course just use a sheet of card or polystyrene to get a similar effect, but for the few pennies reflectors cost, they are worth their weight in gold.
- **Flashgun accessories** – Viewfinder Photography has recently introduced several useful lighting accessories that can be attached to your portable flashgun to modify the light. These new products effectively bridge the gap between studio-based flash and handheld portable flashguns, with snoots, reflectors and diffusers. Each accessory will modify the light in a different way and will add enormous variation to the quality and feel of your flash images.

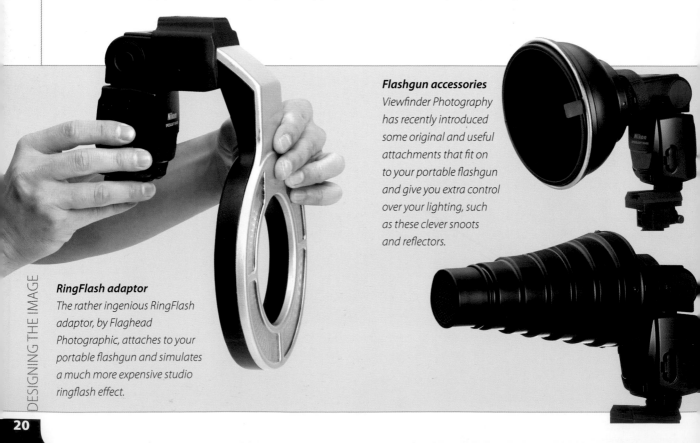

Flashgun accessories
Viewfinder Photography has recently introduced some original and useful attachments that fit on to your portable flashgun and give you extra control over your lighting, such as these clever snoots and reflectors.

RingFlash adaptor
The rather ingenious RingFlash adaptor, by Flaghead Photographic, attaches to your portable flashgun and simulates a much more expensive studio ringflash effect.

OTHER ACCESSORIES

- **Tripod** – in my experience, photographing people tends not to lend itself to the use of a tripod. They are not only heavy, but can also restrict movement, thereby hindering workflow and producing more staged and set-up results. When using flash in a studio, shutter speeds tend to be high enough not to warrant the need for a sturdy tripod and when outdoors, I like to be free to move wherever I want. For these reasons, I rarely use a tripod in my portrait work.

- **Filters** – in the past, the use of glass filters to warm up, soften or create vignette effects in portraits was quite common. However, with digital cameras and Photoshop techniques, it's easier to add all these effects (and many more) when you get back to the comfort of home. The effects can also be done and undone with the click of a mouse so there is no longer the need to get everything exactly right in-camera at the time of shooting. This has been bad news for the filter manufacturers, but great news for photographers who can now play around with effects on the computer until completely happy with the results. Adobe aren't the only software manufacturers to produce filter-effect applications though; you may also like to check out DxO Film Pack and Tiffen DFX – both provide various film/filter-type effects that have been reverse-engineered to simulate the use of traditional photographic materials.

- **Lens shades** – when shooting portraits both indoors and out, stray light can introduce lens flare, which can cause unpleasant and distracting 'hot spots'. Although most new lenses have effective anti-flare coatings, this should not be relied on completely. A good-quality lens shade is an excellent accessory to have at your disposal – and in fact many lenses come with a factory fit shade as standard.

Lauren

This location portrait was shot with a handy Lastolite Tri-Grip Sunlite reflector to add warmth to the model's complexion and to fill in the shadows.
Nikon, 50mm f/1.8 lens, 100 ISO, 1/125sec at f/4.

COMPUTERS AND SOFTWARE

Image-manipulation software has come a long way from the early days to the point where it can now be used as an important tool to extend your creative abilities and workflow. Long gone are the days of being stuck in a small, smelly darkroom with just a red safelight to see with … the electronic revolution is here and long may it stay. Hours spent in the cramped confines of the darkroom processing prints have now been replaced with just minutes in front of your computer and with only a few clicks of the mouse.

It doesn't matter how flashy or expensive your computer system is, or exactly what version of sophisticated software you've got – you must never underestimate the importance of having a good strong image to begin with. No amount of computer wizardry is going to salvage a poorly executed photograph, so try to begin with a correctly exposed, well-composed and imaginative image and don't just rely upon your computer to try to create your masterpieces.

iMac

Apple has always been at the forefront of design and technology. The iMac incorporates an Intel processor that enables the user to work with both Mac OS and Windows applications. Image courtesy of Apple.

MAC OR PC?

Without wishing to stir up a wasps' nest, whether it's an Apple Macintosh running OSX or a PC running Windows, ultimately you'll be able to get much the same results … you'll just take a slightly different road to get there. I've been using Apple Macs since the year dot, when computers were still beige and nerds were still having sleepless nights worrying about the Millennium Bug. It was a steep learning curve with the older operating systems, but when Apple eventually introduced the first version of OSX in 2001, computers just seemed to become so much simpler. Now that Macs have Intel processors, they can even run PC applications to get the best of both worlds. I do have to admit to having a slight bias towards these beautifully designed and engineered machines, and in nearly ten years of using one (several in fact), Macs haven't let me down. If there is one Achilles heel it is that they tend to be more expensive and, if things go wrong, it's not as easy to find an approved Apple repairer as it is a PC engineer. Nevertheless, they are so well made that they rarely do go wrong.

No doubt, you will have already have made your own personal choice for your own reasons, and with a bit of technical know-how, you will be able to utilize technology to produce some inspirational images no matter what computer you are using. However, if you want to use the most up-to-date digital cameras with big file sizes and high megapixel counts, you will need to have a decent spec machine. It doesn't have to be the top model, but one with a fast processor, meaty graphics card and plenty of memory (RAM) will increase your productivity and enjoyment no end. Try to get the fastest machine you can afford, with as much RAM as you can lay your hands on, and don't forget that no matter how much you've already got, you'll never have enough hard-drive space. High-resolution, layered 16-bit digital files eat up memory so try not to skimp here or you'll be forever hungry for more.

PHOTOSHOP

There must be very few people out there who edit digital images who have not heard of Adobe Photoshop. It has taken the market by storm and is generally considered to be the industry standard. Other manufacturers have tried to compete and do things their own way, but if there is one application of choice for digital image manipulation it has got to be Photoshop.

When used by a skilled operator, Photoshop and all its features are limited only by imagination. It's an incredibly complicated

tool that seems to get more powerful the more you learn about it. To be truthful, unless you are a professional photographer who needs to be at the very forefront of digital production, you will probably never really need a full version of Photoshop and you will still be able to produce amazing results with the basic form called Adobe Photoshop Elements. This is a fantastic application with a simplified interface and a wealth of creative abilities. Just about all the main components of its bigger brother are incorporated into a smaller and much more affordable package that does not compromise on quality or usability. If you can't afford the full Photoshop software, try Elements and I'm fairly sure that you won't be disappointed.

FILE FORMATS

Perhaps one of the most important bits of information you will benefit from learning is to always shoot your digital pictures in RAW format – not TIF or JPG. If you want to tweak your images on the computer, RAW files are the way to go. This format effectively produces a digital negative that captures the full capacity of your camera's sensor and will allow you to obtain the very best quality from your digital files. The down side is that the file size is generally three or four times that of a JPG, so your cards will fill up quicker and the burst rate will slow down too. To me, this is a compromise that's worth making as I need to get the best that I can from my equipment and I like to tweak most of my images on the computer when I get back to the studio. RAW files are far more tolerant of exposure errors, while factors such as white balance, sharpness and contrast can all be adjusted later – ultimately giving you far greater consistency and much better results.

To process RAW images, you need to open them up in a RAW converter programme before importing them in to the image-manipulation software such as Photoshop. Once again, there are various converter applications, including Capture One and Bibble, but I find Adobe's own solution to be by far the best and the most intuitive. It's also bundled free with Photoshop, so this is another good reason for experimenting with it before you try some of the other available solutions. Always edit your RAW files in 16-bit colour mode. This effectively doubles the file size but also greatly improves the amount of colour data that is available while working on the digital file. There's no need to save or print the final image in 16-bit mode as it will eat up your hard-drive space no end, but while working on the images, always keep the full 16 bits of data as this will give you maximum quality and help to maintain a smooth histogram in the Levels dialog.

Adobe Photoshop

Photoshop CS3 is currently the market leader in digital image-manipulation software. However, you will be able to produce similar effects in the more affordable Adobe Elements and Corel Paint Shop Pro applications.

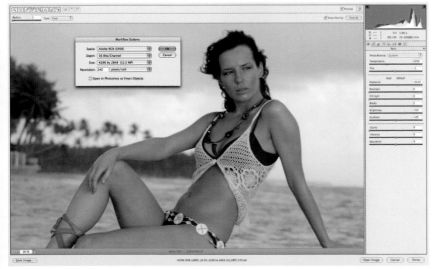

Adobe RAW

The Adobe RAW Converter allows for very precise control over your images before they are worked on in Photoshop.

DIGITIZING FILM

If you want to digitally enhance some old colour film negatives or transparencies, you will need a scanner to convert the film data to a digital file. As digital technology advances, prices have tumbled and quality has soared for desktop film and flatbed scanners. A decent film scanner can give professional results from a correctly exposed and developed negative, and with a bit of practice you should be able to produce high-quality scans that can be printed to A4 (29.7 x 21cm/11¾ x 8¼in) at 300dpi or even larger.

PRINTING

If you want to print out your digital photographs for the family album, a frame or perhaps even exhibitions, you will also need to invest in a decent colour photo printer. Most of the products on the market offer such excellent quality that it's difficult to differentiate the final prints from one model to the next. This is great news for the consumer, as it means you really can't go far wrong with whichever one you decide to purchase, and printers that would have been enormously expensive just a few years ago are now within easy reach of even the tightest budget. Watch out for replacement ink costs though, as these consumables are often where manufacturers make much of their money above the initial hardware costs.

MONITOR CALIBRATION

All makes and models of monitor displays are different and have their own colour characteristics. You only have to look at the huge selection of TV screens in your local electronics store to see just how much the picture varies from one TV to the next, and computer monitors are no different. If you want consistent results, it's important to calibrate your monitor. There are numerous devices available to help with this task, ranging from cheap and very basic to expensive complete colour-profiling systems, but even the simple ones will improve the consistency no end. These 'spyders', as they are known, attach to the screen and the supplied software runs an application that emits different colours on the display. These colours are then compared to a benchmark colour chart and the differences are corrected to create an industry-standard colour profile for your monitor, so that your images will look the same on all correctly calibrated monitors. Models made by Gretag Macbeth and Colorvision are highly recommended.

BACKING UP

Finally, and something that must not be overlooked, is the importance of storing and backing up your digital data. If you've ever been unlucky enough to lose your images when one of your hard drives has gone down, you'll have learnt a very valuable lesson – always back up your files. I keep a copy of my RAW files in three different places: on a main hard drive, on a back-up drive and on good-quality DVDs. Call me paranoid if you like, but I learned the hard way and only wish someone had shared this gem of wisdom with me before I lost hundreds of images and countless hours of work. Back up your data and then back up your back-up.

Dedicated film scanner
The Nikon Coolscan V ED LS50 film scanner is an ideal way to turn your slides or negatives into digital files for Photoshop manipulation.

Monitor calibration
The affordable Colorvision Spyder2Express kit enables you to correctly calibrate your monitor for accurate on-screen colours.

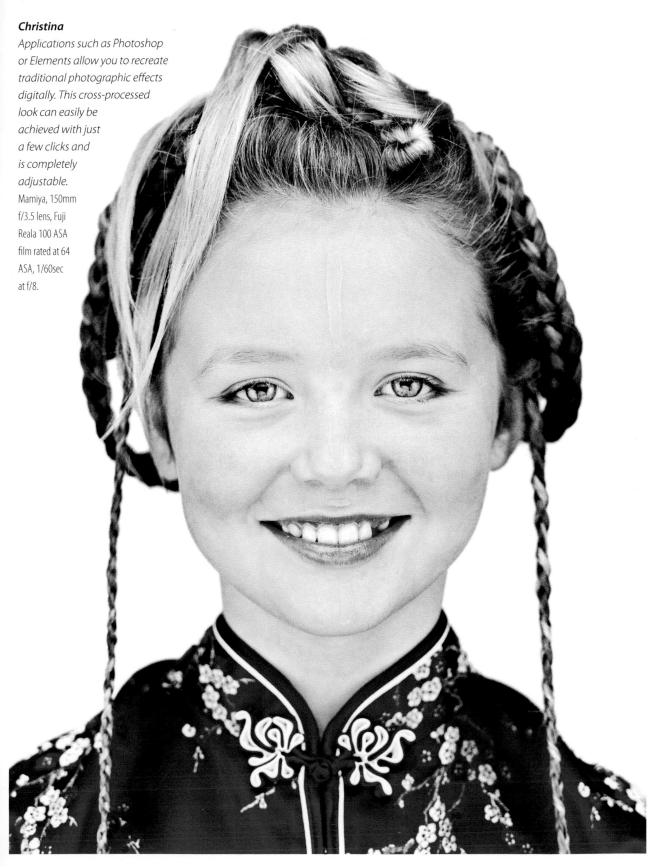

Christina
Applications such as Photoshop or Elements allow you to recreate traditional photographic effects digitally. This cross-processed look can easily be achieved with just a few clicks and is completely adjustable.
Mamiya, 150mm f/3.5 lens, Fuji Reala 100 ASA film rated at 64 ASA, 1/60sec at f/8.

DESIGNING THE IMAGE

A strong composition and good design are all-important in portraiture. While the relevance of subject and the use of light will add to the aesthetics of an image, ultimately the success of the final photograph will be held together by how effectively the image is designed. This chapter helps to demystify the art of shooting striking portraits by explaining the relatively simple techniques and procedures that can be utilized while working on location with your camera and then back at home on the computer. Once mastered, these basic skills will bring a truly professional element to your people photographs.

Ellis
Design and composition are critical factors when it comes to creating outstanding images of people. This engaging portrait demonstrates the strength of a tight crop and the effectiveness of the Golden Rule of Thirds.
Canon, 70–200mm f/4 zoom lens at 200mm, 100 ISO, 1/250sec at f/5.6.

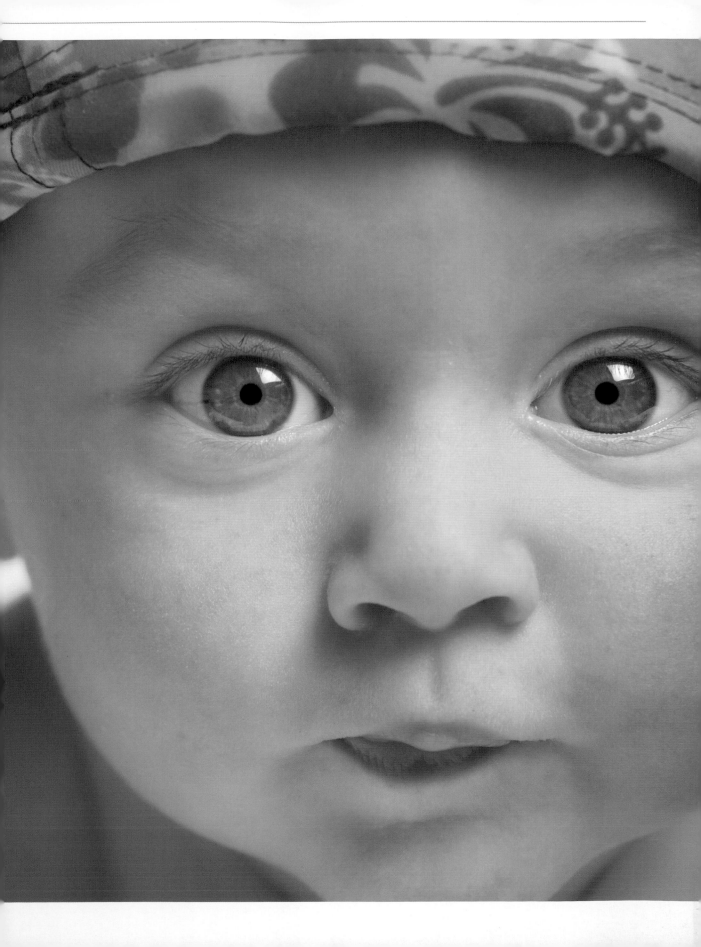

FRAMING AND POSITIONING YOUR SUBJECT

Correctly framing and arranging your subject in your photograph is the first important step in the design of your image. Before you even start thinking about pressing the shutter, you should first be carefully considering where you want to place your subject. Make sure that there are no telephone poles or such like appearing to sprout from the back of their head, and that anything incongruous to the success of your image is skilfully hidden behind your subject. By making minor alterations to your own position and your subject's location within the frame, you should be able to produce a well-composed image with a strong form, clean lines and a distinct shape – all the vital ingredients to a successful portrait.

Photoshop focus

- To give your images a more classical or vintage feel, convert them to black and white (see pages 128–9) and tone them with a warm brown sepia using Image > Adjustments > Color Balance and dialling in some red and yellow to the midtones and shadows.
- To concentrate the viewer's attention on the subject, apply a dark vignette to the edges of the image using the Burn tool. This is an old technique that was often used in the traditional darkroom and can now be easily mimicked in Photoshop.
- To bring back some shadow detail to low-key portraits, dodge the midtones on your subject's face using the Dodge tool.

VENETIAN GONDOLIER

This image was composed to ensure a clean separation between the subject and the shapes and tones of the background. Before I even approached the gondolier, I had decided upon the lens, the basic composition and even the position of his hands in the final image. This meant that I would take up very little of his time, and also allowed me to work under my own steam without having an impatient subject waiting for me. The finer compositional details, such as the placement of his hat under the archway in the background, were only decided once I had started to work with the subject. I chose to position him centrally between the two windows to create a strong symmetry in the image, and by placing his midtoned face against the dark arch the perfect frame was complete.

Kodak, 85mm f/1.8 lens, 160 ISO, 1/250sec at f/4.

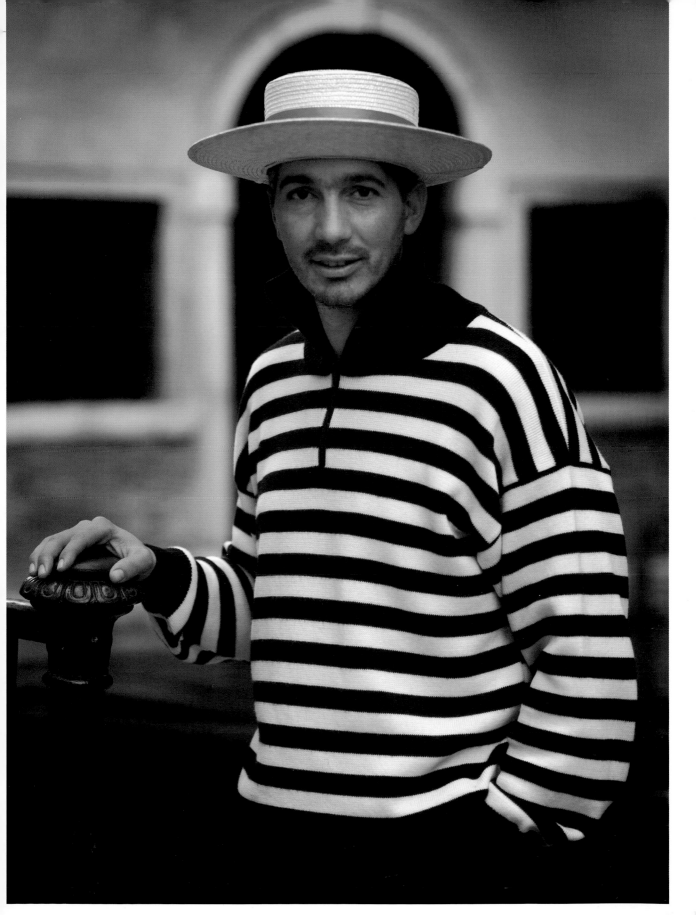

BLUR THE BACKGROUND

When the background behind your subject is a little distracting, why not blur it to isolate your subject and make them stand out? This can be achieved in-camera in a number of different ways, including shooting with a long lens of around 200–300mm and/or shooting at wide apertures such as f/2.0–5.6. In addition to this, the closer the subject is to the camera the more the background will blur. By combining all three techniques, you'll be surprised at just how easily a distracting background can be turned into a smooth transition of colours and tones – creating a perfect backdrop for portraits with impact.

ELLA

This almost candid shot was taken on a beach in early autumn. The bright pink hat contrasts well against the muted yellow of the sand and the pale blue of the sky. Using a long telephoto zoom lens set at around 200mm, with a wide aperture of f/4, and with Ella within talking distance, the background has blurred beautifully to create a strong and clean composition. The little girl has been caught with a wonderfully natural expression of excitement and happiness on her face, and the catchlights in her eyes from the low sun bring her gleeful expression to life. Don't be afraid to shoot plenty of frames to make sure that you catch that 'decisive moment'. Shoot now and edit later.

Nikon, 70–200mm f/2.8 lens at 200mm, 100 ISO, 1/500sec at f/4.

Photoshop focus

- To achieve this effect digitally, the background can be selected and then blurred using one of the many Photoshop Blur filters – my personal favourite is Gaussian Blur (Filter > Blur > Gaussian Blur). A clean selection around the subject can be tricky and time-consuming, so getting the shot right in-camera is much quicker and easier.
- If the background is still distracting, clean it up in Photoshop with the Clone tool and Healing Brush to create a seamless backdrop.
- Pump up the colour saturation (Image > Adjustments > Hue/Saturation) by around +10 to +15.
- If the colours in the image are too cool, add warmth by editing just the yellows in the Hue/Saturation dialog.

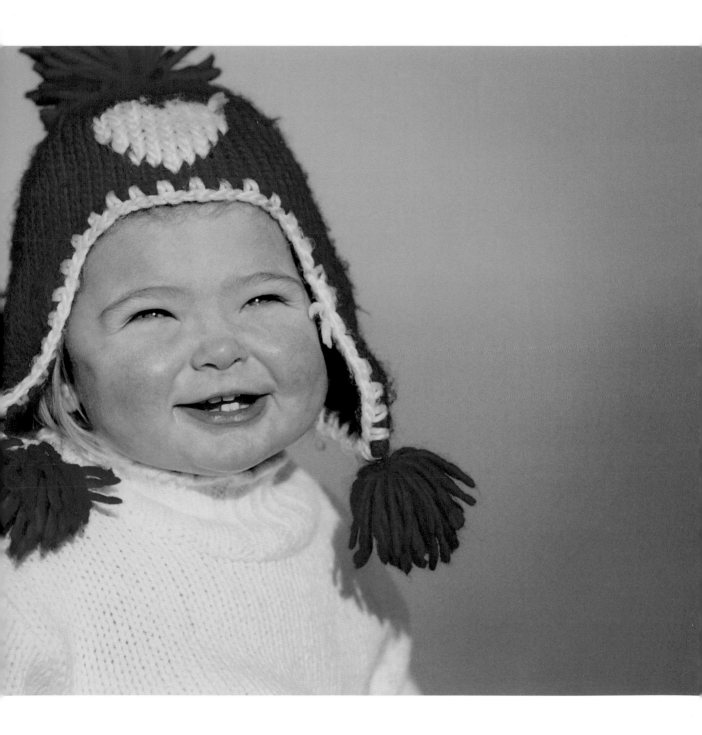

SHOOT FROM AN UNUSUAL ANGLE

Always shooting from eye-level can lead to repetitive and uninspiring shots. Instead, try composing the image from a more unusual angle, which will add drama and impact to your shot. You could try lying on the floor and shooting upwards to get a worm's-eye view or perhaps get your subject to recline against an interesting background and shoot from directly overhead. Hopefully either way will come up with something eye-catching and out of the ordinary. If you do choose to shoot from an alternative viewpoint, make sure you aren't looking up your subject's nostrils and check that they are comfortable with the whole idea. Digital cameras are great for communicating ideas with your subject and creating a vision together, as you can show your sitter exactly what you have in mind by replaying images on the LCD screen.

KAREN

This shot was taken in a busy park in a city centre where it was difficult to find a good clean backdrop. As it was summer and the grass was covered with daisies it made sense to use these strong colours for a fun yet somewhat kitsch model portfolio shot. Karen has great teeth without any fillings so it seemed right to show off this attribute in the image. The shot was lit with natural daylight only – no additional lights or reflectors were used – keeping it nice and simple.

Nikon, 85mm f/1.8 lens, 100 ISO, 1/125sec at f/5.6.

Photoshop focus

- When including flowers in your pictures, make sure they are perfect specimens. If not, use the Clone tool to replace any that have been nibbled by caterpillars with pristine new ones.
- Warm the RAW file up in the converter software by tweaking the colour temperature slider until you are happy with the effect. This negates the need to use a warming filter over the lens, thereby keeping lens sharpness/resolution to an absolute maximum and reducing the weight of your kit.
- Eyes and teeth can be quickly lightened using the Dodge tool with a soft brush to give a more commercial look.
- Pump up the colour saturation by around +20 to add to the almost surreal feel of the final image and to make it visually bolder.

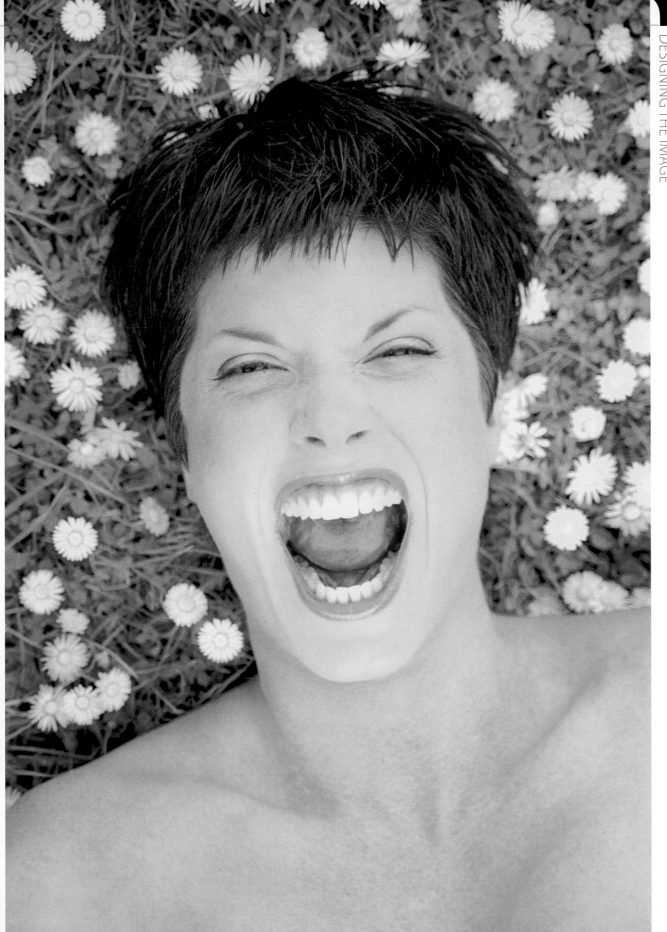

ZOOM IN FOR IMPACT

Robert Capa, the celebrated war photographer, said, 'If your pictures are not good enough, you're not close enough.' The 1.5x crop factor of many digital cameras means it's possible to zoom in really tight to fill the frame with your subject's expression. Such close focus has inherently shallow depth of field, so be extra careful and take your time to make sure you get the focus spot-on. In all types of portraits it's crucial to focus on the subject's eyes. If depth of field is really shallow and you can keep only one eye sharp, make it the one that is closest to the lens. Filling the frame with the subject's face is also useful for removing a distracting background and can be a useful technique to employ when you need to shoot a strong portrait in a poor location.

MACKENZIE

This candid shot seems to encapsulate the innocence and wonder of youth. It shows a pure, natural and slightly ambiguous expression that can only be captured, not created. If you ask a two-year-old child to pose for you, the end result will be static and staged, not to mention frustrating to articulate. You need to be fast and familiar with your equipment to make sure you don't miss the moment – don't hesitate or you'll miss it just by thinking about it. I used a long telephoto lens at its maximum extension of 300mm to capture this image on a full-frame digital camera. It was not a particularly fast lens in light-gathering terms and it was a little slow to auto-focus, but with some practice and skill I was able to get the shot. The minimum focus was around 1.5m (5ft) away, so I zoomed in to fill the frame for maximum impact.

Nikon, 70–300mm f/4–5.6 zoom lens at 300mm, 160 ISO, 1/250sec at f/8.

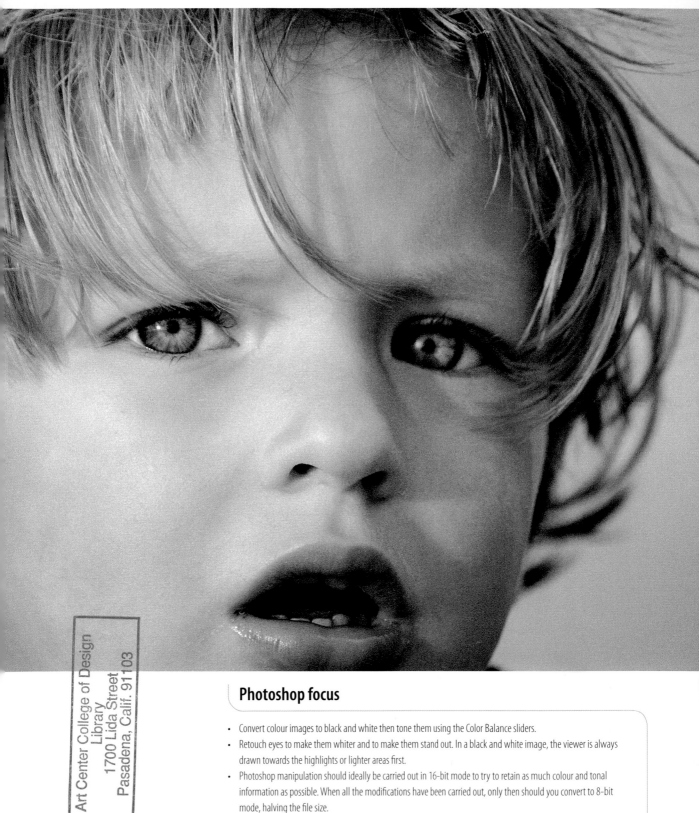

Photoshop focus

- Convert colour images to black and white then tone them using the Color Balance sliders.
- Retouch eyes to make them whiter and to make them stand out. In a black and white image, the viewer is always drawn towards the highlights or lighter areas first.
- Photoshop manipulation should ideally be carried out in 16-bit mode to try to retain as much colour and tonal information as possible. When all the modifications have been carried out, only then should you convert to 8-bit mode, halving the file size.
- When a face fills the frame you need to be sure there are no imperfections to distract the viewer's eye. Children's skin tends to be so 'peachy' pure that little or no cloning needs to be applied, but if your subject is older use the Clone tool to remove any unsightly blemishes.

ANGLE THE IMAGE FOR DRAMA

In landscape or architectural photography, a level horizon is often paramount to the success of the image, but in portraiture keeping everything straight is less of a constraint. Remember that compositional rules are never set in stone and are made to be broken if you feel confident enough. It's important to consider the effect of the horizon on the composition and design, but placing it down the centre of the frame at an angle often works well. A tilted horizon adds a certain tension to the picture by creating drama, dynamism and by injecting life into an otherwise static composition. As long as the basic elements are well-balanced in the overall composition, this technique can produce strong images with a contemporary feel.

RICHARD

This image, shot for a young dancer's model portfolio, breaks many of the basic rules of traditional composition, but still works. Admittedly, I've positioned the subject in the right-hand side of the frame and observed the Golden Rule of Thirds, but the horizon is angled to add extra impact. The dancer's balancing skills were brought in to play by getting him to perform a handstand. This helped to create an unusual portrait that reveals a little more about the individual and his character. A medium-length telephoto lens and a wider aperture were used to isolate the subject by slightly blurring the background.

Mamiya,150mm lens, Fuji Reala 100 ASA film rated at 64 ASA, 1/500sec at f/8.

Photoshop focus

- This image was shot on medium-format colour negative film, which was scanned in at 2,400dpi to create a 120MB 16-bit digital file. When scanning film it's important to set the correct film profile in the scanning software. Silverfast Ai by LaserSoft Imaging, for example, has dozens of bespoke film curves and settings that make it easy to get well-balanced colour scans from a desktop scanner. Some types and brands of film scan better then others, and it's something of a trial-and-error process to work towards consistently getting the result you want.
- A slight blue gradient can be added to skies to inject a little colour. While this could be done using a graduated filter in-camera, it's easier to get the desired effect in Photoshop. Duplicate the background layer (Layer > Duplicate Layer), so as to leave the original image intact, then add a gradient using the Gradient tool and selecting a colour from the Swatches palette. Finally, fade the layer Opacity back to get the right depth of colour.

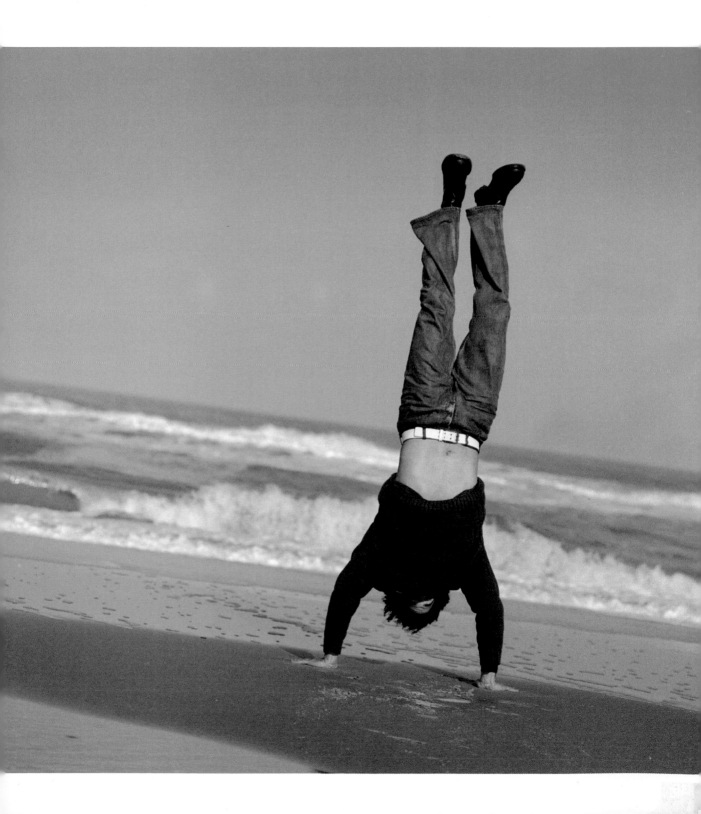

SHOOT KIDS FROM A LOW VIEWPOINT

The angle from which you take pictures will have an enormous effect on the impact of your final image and what you actually say about your subject. By shooting children from a low viewpoint, you are not only creating a more interesting photograph, but you are also empowering your subject by emphasizing their importance in spite of their diminutive size. As adults we are used to looking downwards at children, so getting down to their level will provide an unusual angle, showing them in a different light, and bringing a new dimension to your portraits. Lower viewpoints also help to isolate your subject against a clear background such as the sky. Again, this is an effective technique to employ when the background is not very photogenic or when it adds little to the message you are trying to convey.

MACKENZIE

This shot was another fleeting moment that seems to capture the vitality of youth. I used a longer lens to throw the distracting background out of focus and a low viewpoint to inject energy into the composition. This dynamic perspective works together with the bright colours of the coat and scarf to produce a photo with strong visual impact.

Nikon, 70–200mm f/2.8 lens at 135mm, 100 ISO, 1/500sec at f/4.

Photoshop focus

- To tone down the cold blue colour temperature of autumnal light, add warmth in the RAW converter software by tweaking the colour temperature slider, or choose a different white balance preset, such as Daylight, Cloudy or Shade.
- Pump up colour saturation to give a vibrant Fuji film-like feel. Since you can no longer pick and choose the colour characteristic and tone curves of traditional silver gelatin-based films, these differences now have to be emulated digitally. This can be done with a little experimentation in Photoshop, or alternatively, software developers such as DxO Optics manufacture filter plug-ins that work with Photoshop to simulate these old film-style effects.

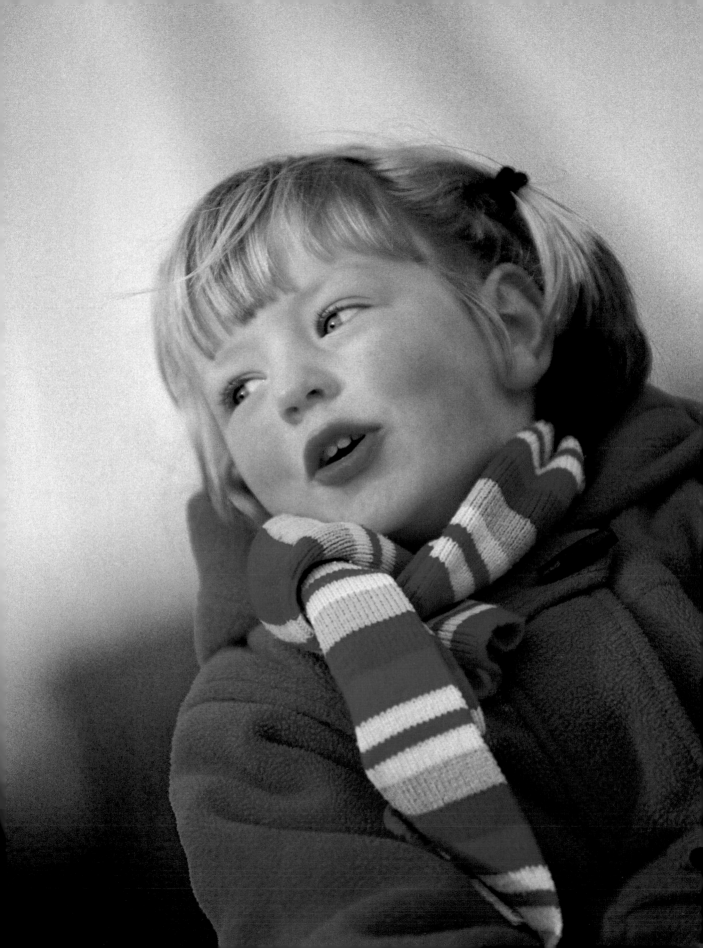

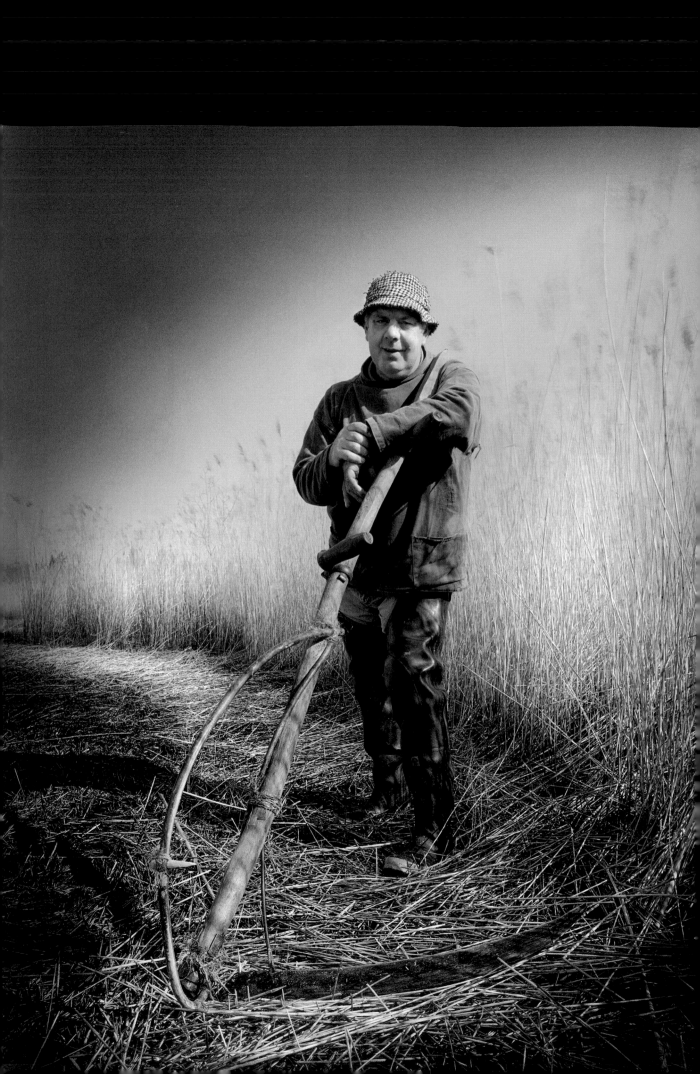

USE A WIDE-ANGLE LENS TO EXAGGERATE PERSPECTIVE

Wide-angle lenses can be used to great effect in the designing of certain types of portraits. Due to the inherent optical characteristics of a wide-angle lens, they tend to exaggerate perspective by emphasizing the foreground and creating a strong sense of depth. This can be especially useful when shooting 'environmental' portraits as it's possible to photograph both the subject and the location and, by doing so, the image will tell more of a story about the sitter. While a wide-angle lens can be a very powerful tool, it does need to be used with some caution and a little thought. Wide-angles are great for dramatic images, but they are not so good when trying to produce a flattering portrait. Used close up, they can create unwanted perspective distortion, which could mean a somewhat alien-shaped head or a bulbous nose; something your sitter will not thank you for.

ERIC

This portrait of a reed cutter with his wooden scythe uses a 28mm lens to dramatically enlarge the sharp blade of his handmade tool. The strong perspective effect runs from the blade edge in the immediate foreground to the distant reed beds, which sweep around the back of the subject creating a strong sense of place and revealing the environment he works in. It's often difficult to judge the exact effect of a wide-angle lens, as the perspective is so different from your normal day-to-day vision. It's therefore a good idea to think about what effect you want to create and then select the right lens for the job while looking through the viewfinder.

Canon, 24–105 mm f/4 zoom lens at 28mm, 100 ISO, 1/60sec at f/16.

Photoshop focus

- Convert colour images to black and white, then add a sepia tint to give a traditional feel.
- Use the Burn tool to burn in the sky area and the foreground with a soft brush at around 25% Exposure to spotlight your subject, almost like an actor would be lit upon a stage.
- If the light is quite harsh, expose the image with plenty of shadow detail (so the subject's eyes do not go black beneath his hat) while still retaining full detail in the highlight areas. If this is not possible in-camera, select the area with the Lasso tool, feather the selection (Select > Feather), then use the Shadow/Highlight dialog (Image > Adjustments > Shadow/Highlight) to achieve the right balance.

USE A TELEPHOTO LENS TO COMPRESS PERSPECTIVE

In the opposite way to how a wide-angle lens exaggerates the perspective in an image, a longer telephoto lens can be used to compress the depth plane. Lenses in the range of 75–135mm (50–90mm on a cropped image sensor) are often referred to as 'portrait lenses' and are favoured by photographers for the very flattering effect they have on the majority of subjects. They also allow a reasonable distance between the photographer and the sitter, making the process less intrusive and intimidating, while maintaining a tight composition. A telephoto lens of around 200–300mm can be used to compress the perspective of your subject's facial features. This can be a very useful technique to employ if your sitter has a particularly prominent nose or jaw line, as the longer lens will help to take the emphasis off it and disguise it somewhat.

MICHELLE AND ELLIS

This image was taken in the studio using a small Elinchrom softbox. The shallow depth of field and close focus of a long telephoto lens has helped to soften the overall appearance of the shot while concentrating the viewer's attention on the baby's eyes. The lens has also allowed a strong, close crop that aids the overall design of the image and eliminates most of the background.

Canon, 70–200mm f/4 lens at 200mm, 100 ISO, 1/250sec at f/4.5.

Photoshop focus

- Due to limited depth of field, a telephoto lens will throw much of the subject out of focus, but you can soften parts of the image further with some additional Gaussian Blur.
- For a sensual subject such as this, tweak the colour balance in the RAW converter software to add extra warmth. This will give the skin tones a slightly tanned look that makes the image feel more intimate and inviting. This can also be done with a Photo Filter adjustment layer (Layer > New Adjustment Layer > Photo Filter) and an 85 orange warming filter.

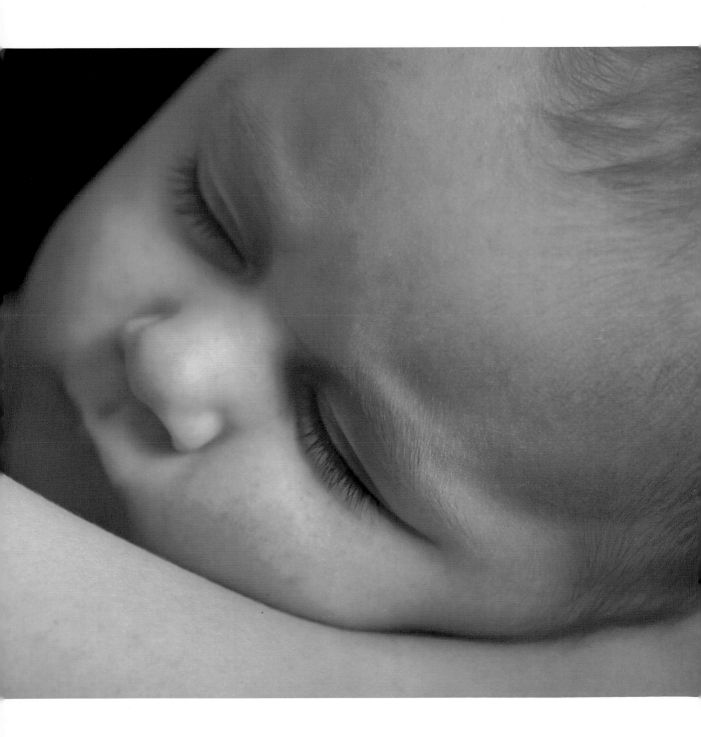

USE ACCENT COLOURS

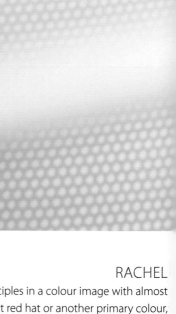

The use of strong colours can be a powerful way of composing visually compelling images. Juxtaposing bold shades such as reds, blues and greens can create concordance or discordance in a shot, thereby generating a certain mood or tension. This is a well-known and often-tried technique that can become a little tiresome if used too often, so why not try something slightly different? By using colour a little more cautiously – perhaps a single accent shade or tone – it's possible to emphasize your subject just as effectively. The subtle use of muted colours in an image with a splash of a discordant colour can prove to be an equally successful way of creating a photograph with a strong and vivid composition – sometimes less really is more. This technique can be just as useful when working in black and white. Instead of using bright primary colours, try placing contrasting tones together, such as black against a white background or highlights against a midtone grey.

RACHEL

This model portfolio shot combines these principles in a colour image with almost monochrome tones. I could have added a bright red hat or another primary colour, but that seemed a little too obvious, so I chose to use a black hat against the pale-coloured wall and spiral staircase. The bold white line of the metal staircase leads the eye from bottom left up towards the model and further enhances the composition. I shot some images with her smiling but in the end I preferred the more pensive look.

Nikon, 70–200mm f/2.8 lens at 200mm, 100 ISO, 1/250sec at f/4.

Photoshop focus

- Selecting a Cloudy white balance setting in the RAW converter software will help to warm up otherwise cold tones.
- Watch out for heavy shadows whenever the face is covered as you can lose detail and those all-important catchlights. If your subject's face is slightly too shadowed beneath a hat, select the face with the Lasso tool, feather the selection and then use the Shadow/Highlight dialog with the Shadow Recovery Amount set to around 10% to bring back some detail.
- The edges of the original image were a little dark due to the long focal length and wide aperture on a full-frame camera causing vignetting. This can easily be remedied in Adobe RAW Converter by choosing Lens Correction and sliding the Amount to around 50.

USE SELECTIVE FOCUS

Selective, or differential, focus is a very powerful in-camera technique that will help add style and finesse to your images. The effect is largely achieved with a combination of close focus, wide aperture and long lens. Although a similar result can be created in Photoshop, it's long-winded, fiddly and much more difficult to produce a natural-looking image. Another factor that can help to create differential focus is digital sensor size. Depth of field becomes greater the smaller the sensor: it is harder to throw your subject off focus with smaller sensors. This accounts for why some professional photographers like to shoot their portraits using medium-format digital backs, as it gives them greater control over what is and isn't in focus – a very useful creative tool. DX size or cropped sensors have even more depth of field at a given focal length and aperture, so it becomes even harder to use the selective focus technique. With all this in mind, if you want your subject to be unsharp, you must try to use a combination of these factors and then a little bit of Photoshop trickery too.

Photoshop focus

- Most of the selective focus effect should be generated using in-camera techniques. However, if you find that the background could benefit from a little more blur, use a Selection tool to roughly select the area you want in focus, feather this selection with a wide radius and then invert it (Select > Inverse) and save it (Select > Save Selection).
- Duplicate the background layer, load the saved selection (Select > Load Selection) and then add Gaussian Blur with a radius of 5 pixels. The amount of blur needed will depend upon the resolution of the image. You may also like to try some of the other Blur filters such as Lens Blur, but bear in mind that some of these more complex filters make extra demands on your system's memory and processor.

TAMSYN AND ALI

This image was taken as part of a magazine fashion shoot. Emphasis was placed on the female model in the foreground by selecting a wide aperture on a full-frame camera with a 135mm lens at f/2.8. I wanted to throw the male model in the background out of focus, so I had to use the depth of field preview button and the LCD screen to check the effect. Only when I was happy with the degree of focus did I commence with the shoot. I also added a slight tilt to the image to make it less static and give it more of a reportage feel, almost as if it were a candid image.

Canon, 135mm f/2.8 lens, 200 ISO, 1/500sec at f/2.8.

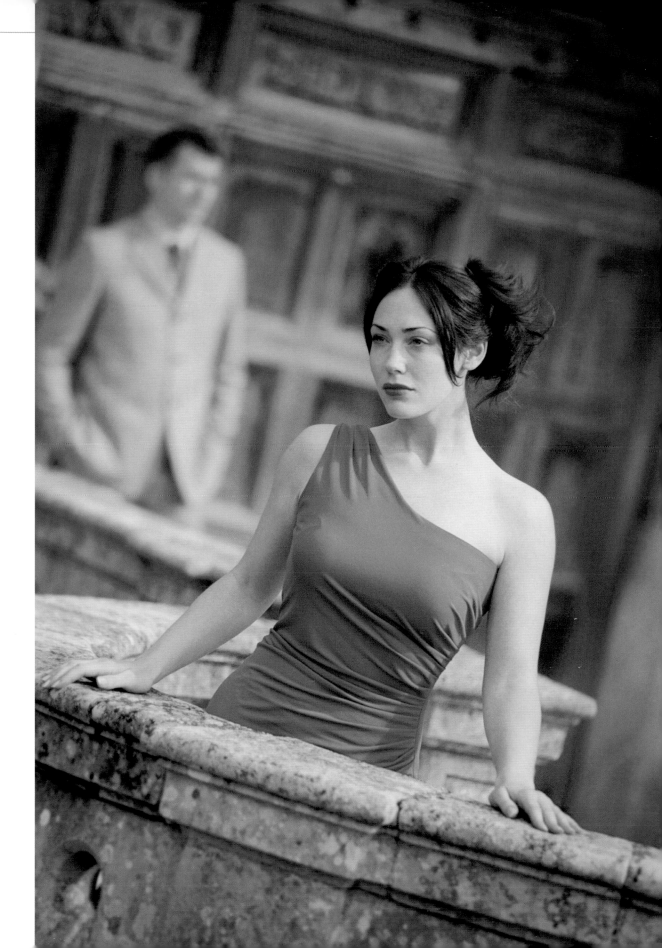

PUSH YOUR CREATIVITY

When photographing people, don't always take the traditional approach. From time to time, push the boundaries of your creativity and shoot your subject in a more unconventional way. For example, why not shoot the back of your sitter's head, or perhaps close in on the bony, gnarled hands of a wrinkled old man? Either way, your images should still tell a story, but they will take on a new artistic dimension that stretches traditional portraiture to the max. This originality is what great photography is all about and will help lift your people pictures above more orthodox and mainstream styles. By choosing to photograph your subject in this way, you may also find that you need to worry less about your people skills, as you probably won't be showing their face. This is a particularly useful technique to adopt when your subject is obviously uncomfortable about being photographed and when they seem unable to relax in front of the lens.

SPLASH

This image of a young girl splashing around in the surf on a warm summer's day encapsulates fun. The idea developed slowly as I stood knee deep in the waves, trying to shoot the girl as she ran through water. Initially, I took a wider view and tried to capture her facial expressions, but then I began to use my imagination to produce something a little more contemporary. The image is original in its approach to the subject and yet it still successfully captures the energy and rush of the whole experience in a fresh and dynamic way.

Nikon DX, 70–200mm f/2.8 zoom lens at 200mm, 100 ISO, 1/640sec at f/5.

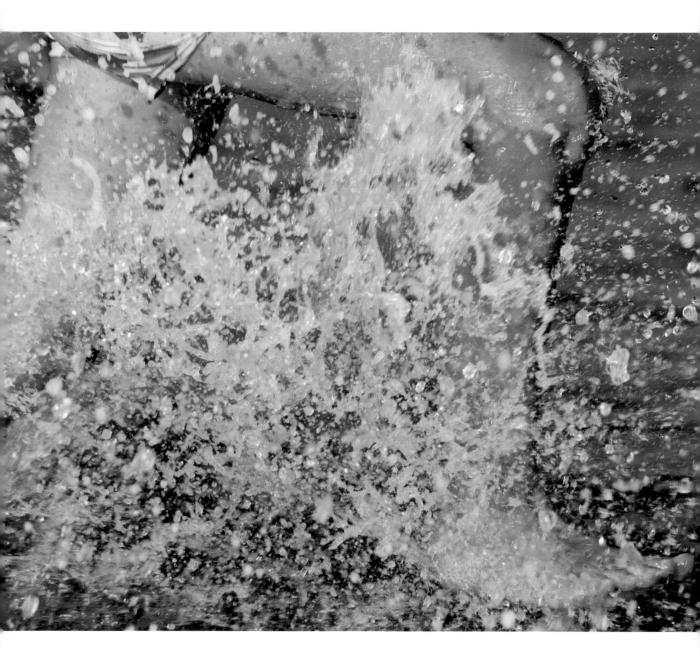

Photoshop focus

- White surf may cause the meter to underexpose the image by around ¾ stop. Lighten it up in the RAW converter software by sliding the Exposure slider to around +0.75. This will clean up the highlights and make the whites white again.
- Pump up the saturation in the RAW converter software by around +10 to add more punch to the colours.

CHOOSE INTERESTING LOCATIONS

Although portrait photographs are primarily about the people in them, the importance and relevance of the backdrop must not be underestimated. To design a really strong image, it's necessary to think about all the elements that will appear in the shot and ensure they add to the style and feel of the final image. For example, with a colour photograph, ask yourself whether the shades are concordant or discordant with your subject. With black and white images, think about whether the tones will work with or against your subject and whether they will support your creative vision. Above all, do not include anything in the frame that will be distracting or will not add to the message that you want to communicate; and keep it simple. These principles apply equally to work on location and in the studio.

BRIEF ENCOUNTER

For this image, I was asked by Visit Britain to recreate the farewell scene from the classic black and white film *Brief Encounter* but with a modern twist. The location was Carnforth Station in Cumbria, England, which is still a busy working railway station. I moved a few props around to aid the composition and prominently included the original platform clock, which played such a significant part in the screenplay. I then waited for the train to arrive and had only a few seconds to shoot before the passengers disembarked and messed up the clean design. A standard lens was used with a wide aperture to partially blur the background while maintaining the integrity of the composition.
Canon, 50mm f/1.4 lens, 100 ISO, 1/15sec at f/4.

Photoshop focus

- When shooting digitally you are free to choose either colour or black and white for your final image. In this instance, I felt that it would be in keeping with the original concept to convert the colour image to mono and add an old-fashioned sepia tone.
- Add toning effects on a duplicate layer so that the integrity of the original colour image remains intact.
- The Burn tool (set to around 10% Exposure) can be used to add to the atmosphere by darkening the midtone edges of the frame, thereby highlighting the focal point.

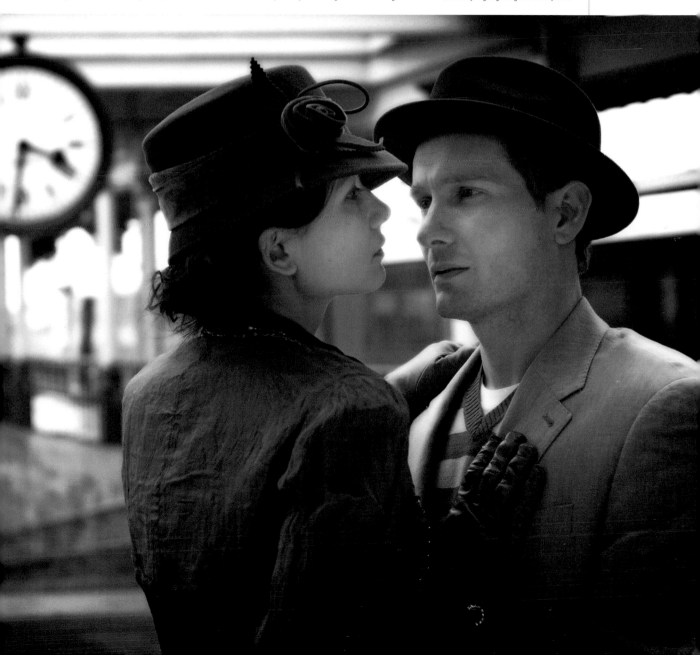

MIX COLOUR AND MONOCHROME

One of the wonderful things about shooting digitally is that, as long as you shoot in RAW format, everything is captured with full colour data, which means you can always decide to convert it to black and white when you get back to the studio. This was not possible when using film – you had to decide on whether to shoot colour or black and white in-camera. I've lost count of the number of times I've shot an artistic image in black and white and then been asked for it in colour … all very frustrating. But this problem is solved in the digital darkroom, as even if an image is shot on colour film, it's possible to scan it, digitize it and then change the colour image to black and white. A particularly interesting effect can be created when mixing both colour and monochrome and this can quite easily be done with the use of layers and masks in Photoshop. The use of a splash of colour in an otherwise black and white image helps highlight important parts of the shot and leads the viewer's eye to the focal points.

QUALITY ROSE

This image was shot for Visit Britain to illustrate an advert for their Quality Rose accommodation awards. It was photographed on a rather flat and dull winter's day where the colour temperature of the light was cool and uninspiring. I could have used a blip of fill flash to brighten things up, but it might have ruined the soft romantic atmosphere that was created here, so instead I decided to turn it into a black and white. The roses were such a passionate red that I chose to keep their colour and desaturate the rest of the image, apart from the Quality Rose sign in the background. Black and white often works well on dull and overcast days when the colour of the light is less than ideal.

Nikon DX, 50mm f/1.8 lens, 200 ISO, 1/200sec at f/4.2.

Photoshop focus

- Duplicate the colour image on to a second layer so you can make changes without disturbing the original image file.
- Desaturate the duplicate layer and carefully erase the elements that you want to keep in colour at 200% magnification with the Eraser tool and a small, relatively hard-edged brush. This will erase the mono layer to reveal the colour layer beneath.
- Tone the final monochrome image with a warm sepia shade to add to the romantic feel.

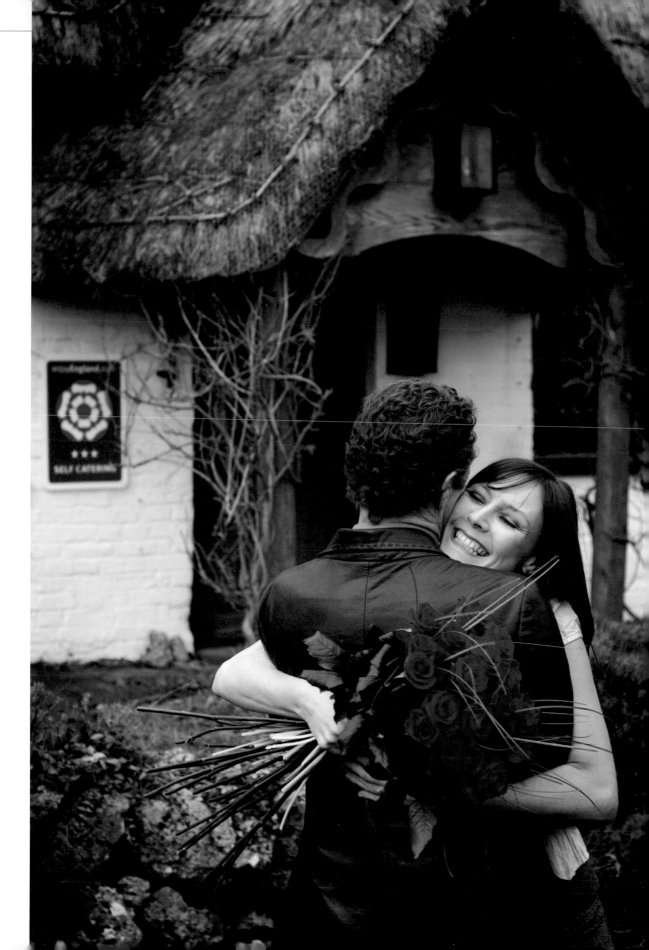

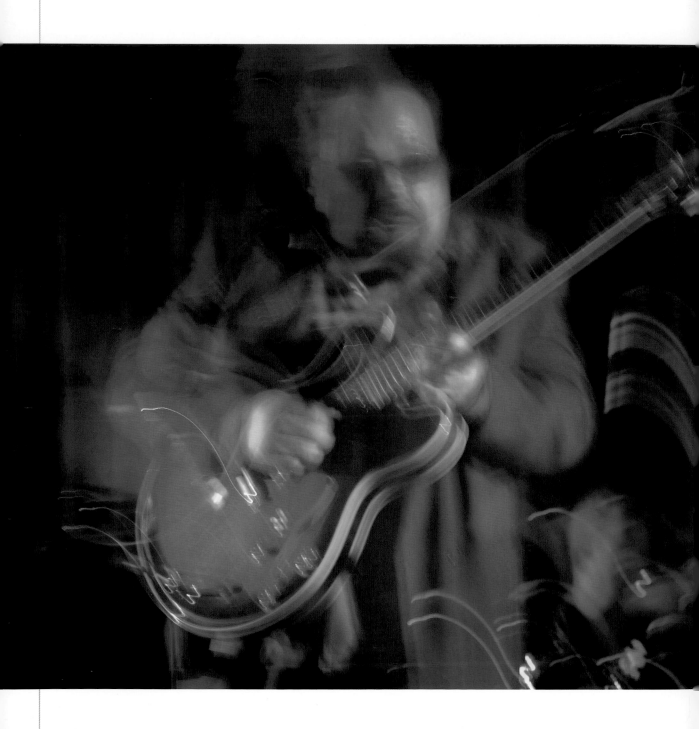

SHOOT LONGER EXPOSURES

One of the greatest appeals of photography as an art form is that the camera is able to capture just a fraction of a second and freeze that special moment in time. This is what defines our more traditional photographic preconceptions, but why not try and stretch these creative limitations to produce something more exciting? Using longer exposure times you can make an image that explodes the boundaries of conventional photography and reaches into the realms of impressionistic art. The technique can be a little hit-and-miss, as you cannot predict exactly how the image will look, but this is another reason why a digital camera is such a useful tool – you can replay the image on the LCD screen just seconds after the shutter has been released. This will give you instant feedback and allow you to fine-tune the precise shutter speed to create the effect you are after.

OTIS GRAND

This image of the famous blues guitarist was shot on a very dark stage that was lit by coloured gels from the stage lights with very little ambient light. I had shot several frames where I tried to freeze the action, but even at 3,200 ISO and with a 24–105mm image-stabilization f/4 zoom lens, the exposures were around 1/15sec. Using a fast telephoto lens and shooting at around f/2 did not help either, as the depth of field was very shallow, and it was tricky to track the energetic guitarist. Portable flash would have ruined the ambience, so instead I decided to set the sensor sensitivity to 200 ISO and try a much longer exposure. The subject blur seemed to help convey the life and passion of his performance. The light trails created by the movement could not be predicted, so I shot plenty of frames.

Canon, 24–105mm f/4 IS lens at 75mm, 200 ISO, 1/2sec at f/4.

Photoshop focus

- This technique needs to be mastered in-camera rather than in Photoshop. However, you might choose to darken the background by making a rough selection around the subject, feathering at 250 pixels, inverting and then tweaking the Levels (Image > Adjustments > Levels) to create a loose vignette, which helps to concentrate the viewer's attention on the subject.
- Adjust the colour balance in the RAW converter software to produce a colour temperature that is appropriate to the feel of the image.

USE SHAPES AND LINES FOR STRONG COMPOSITIONS

Many inexperienced photographers forget that considerable thought should be given to the basic design of all their portraits. While people photography is about portraying the character of your subject in your images, really good portraiture should go beyond this. By carefully composing your shots, you will be able to produce visually compelling images that transcend basic portraiture and can be identified as true works of art. In order to do this, your images will need to display an understanding of the basic rules of composition. This includes the Golden Rule of Thirds, strong shapes and symmetry, lines to lead the eye around to the picture and diagonals to add drama and tension to your shot. Good design skills can be learned and once mastered, effective composition will become easier and more intuitive.

Photoshop focus

- If shooting in RAW mode using auto white balance under mixed lighting conditions (fluorescent and tungsten, here), the image is likely to display different colour casts. One way to get round this is to convert to black and white, or select the predominant lighting source.
- Use the Burn tool to darken the shadow areas of the image, thereby bringing out the midtones of the subject's face.

TOM

This shot of fellow photographer Tom Mackie uses shapes, light and strong lines to lead the viewer's eye around the image towards the subject posed on a spiral staircase. Using the Golden Rule of Thirds, he is positioned in the lower right section of the image, creating a perfectly balanced composition. Due to the very low levels of available light I needed to set a long exposure, so this is one of the rare instances where I used a tripod. The subject is also positioned within a large triangular shape, which adds dynamism to the shot and frames him perfectly.

Kodak, 17–35mm f/2.8 lens at 24mm, 160 ISO, 4sec at f/5.6.

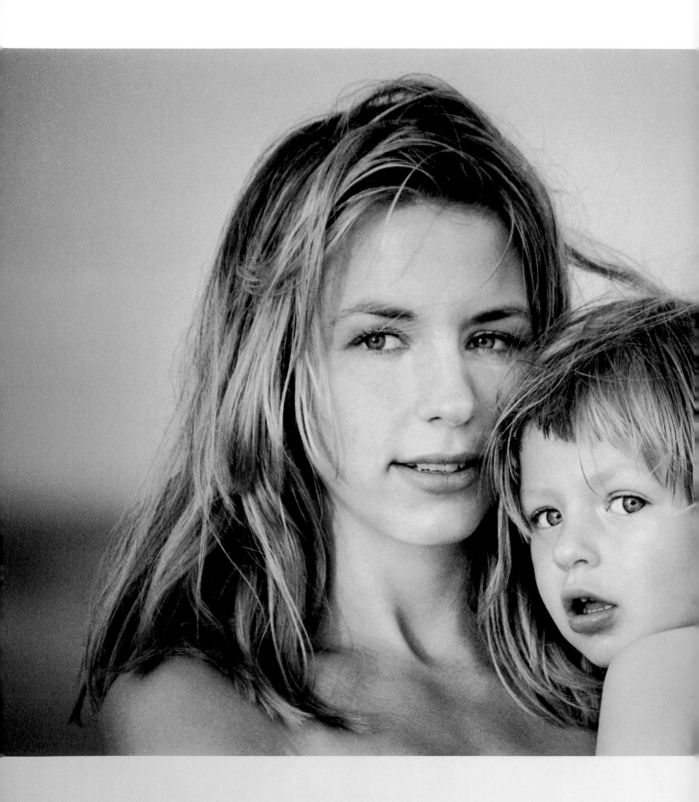

WORKING WITH LIGHT

Photography is the art of painting with light. The importance of the quality of light must never be underestimated in your portrait work. Whether the light is soft, hard, cold or warm, its characteristics will all have an enormous bearing on the success of the final image and the message it conveys. Often forgotten, but of equal importance, is the converse of light – shadow. To be a successful photographer you must use the subtle intricacies of both light and shadow to help sculpt your vision and create the desired atmosphere. Ultimately, it is the understanding and mastery of this craft that will make you a better photographer and make your images more than mere snapshots.

Jenny and Mackenzie
You do not need to spend a fortune on expensive studio lighting equipment to achieve fabulous photographs of people. Natural daylight, with all its subtle colours, tones and variations, can produce truly beautiful results.
Nikon, 70–300mm f/4–5.6 zoom lens at 300mm, Kodak T-Max 400 ASA film, 1/500sec at f/5.6.

USE SOFT LIGHT

When shooting outdoors, harsh directional sunlight can cause areas of deep shadow that spoil the mood of a portrait. Instead, try shooting in the soft light of open shade to create diffusely lit images, which will often prove more flattering to your subject. When shooting in the shade, the mild, almost shadowless quality of light is gentle on skin tones and textures and gives a similar effect to using a huge overhead softbox in a studio set-up. Professional studio photographers frequently try to emulate this type of lighting, but this natural source of daylight is the real thing, and better than that … it's free.

Photoshop focus

- To reduce a cool blue colour cast, warm up the image in one of several ways. First, you could increase the temperature of the white balance in the RAW converter software by shifting the slider to the right. If you are not shooting in RAW, instead try using the 81A Photo Filter effect in Photoshop CS3 (Image > Adjustments > Photo Filter); or, if you are using Photoshop Elements, by enhancing it in the Adjust Colour for Skin Tones dialog.
- Remove any blemishes on your subject's skin with the Clone tool and Healing Brush and enhance the eyes using the Dodge and Burn tools.
- A mild cross-processed effect can be added using a Curves adjustment layer (Layer > New Adjustment Layer > Curves), and bending a slight 'S' shape in the tone curve, which darkens the shadows and lightens the pale face tones.

LAUREN

This image was shot using soft, natural light in open shade cast by nearby beach huts. A white Lastolite reflector was also used directly below the model's face to bounce light into the shadows, to add catchlights to her eyes and to soften the light even further, resulting in a very flattering portrait. However, since the main light was coming directly from the cloudless, blue sky above, the image was a little cool and needed some warming up. This can either be done in-camera with a mild warm-up filter such as an 81A, or it could more easily be done digitally in post-production.

Nikon, 85mm f/1.8 lens, Fuji Reala 100 ASA film rated at 64 ASA, 1/250sec at f/5.6

USE WINDOW LIGHT

The subtle and delicate quality of light that a window can transmit is perfect for many types of portraits. On an overcast day, window light is wonderfully diffuse and has a very flattering effect on skin tones and textures. The resulting images will have a natural and timeless quality about them that no other kind of indoor portrait can match. Best of all, window light is free and when the conditions are right, absolutely no additional equipment is needed. However, on a bright sunny day you need to take care, as window light can be somewhat high-contrast, and it can be difficult to balance the dark shadows of an interior with the bright highlights of the window. Always review the image on the LCD screen and tweak the exposure to obtain the best results, remembering to hold detail in the highlights of your subject's face. Don't include the actual window in the image, as it will more than likely burn out and ruin the shot. Instead, go for a closer crop of the head and shoulders. If you find the contrast is still too great, try using a small reflector to bounce light back in to the shadows.

EMILY

This is a fine example of the use of window light on an overcast winter afternoon. The soft tones of Emily's skin are captured in a very gentle way that emphasizes her prettiness and femininity. By closing in on her face and ensuring that her skin tones are correctly exposed, I've been able to produce a beautiful and alluring portrait that could not have been bettered in an expensive studio.

Canon, 50mm f/1.2 lens, 200 ISO, 1/160sec at f/2.

Photoshop focus

- If you have used the light from a north-facing window, you will probably find it needs a little warming up in the RAW converter software to produce a pleasing effect.
- Achieve perfect complexions using the Clone and Healing Brush tools.
- Lighten the whites of eyes with the Dodge tool set to Highlights and a small Exposure of around 5% to keep the results from looking too false.

USE A REFLECTOR

While ambient light provides a whole host of opportunities to produce stunning portraits, unmodified natural light can sometimes be restrictive and will need a little extra help. In the studio, you can adjust your light source by filtering, using various attachments and fine-tuning the quantity as well as the quality of the light. However, when using daylight on location, this flexibility is somewhat limited and the use of a few portable accessories can make the world of a difference to your results. Lighting add-ons come in many shapes and sizes, but I find the range of products manufactured by Lastolite to be unparalleled. They are high quality, lightweight, affordable, well designed and can be folded up into small bags for ease of transportation. Light-modifying accessories will allow you at least some degree of control over the ambient light and will bring a truly professional touch to your people photographs.

Photoshop focus

- Convert colour shots to black and white.
- Draw the viewer's attention to the subject without being too obvious using a loose vignette. Roughly select the subject with the oval Selection tool, then feather the selection by 250 pixels and invert it. Then create a Levels adjustment layer (Layer > New Adjustment Layer > Levels) and slide the midtones slider to around 0.85 to darken the selection.
- Any minor imperfections can be tidied up with the Clone tool to create the perfect backdrop.

JENNY

This image was taken in the late afternoon sun of a mid-summer's day. The light was largely from the left, so this created rather harsh shadows on the opposite side of Jenny's face. I used a medium-sized white Lastolite reflector to bounce some light back in to the shade, thereby softening the glow that was hitting her face. This, along with the reflective quality of the sand, helped to create a beautiful, natural portrait
Nikon, 70–300mm f/4–5.6 zoom lens at 200mm, 400 ISO, 1/250sec at f/8

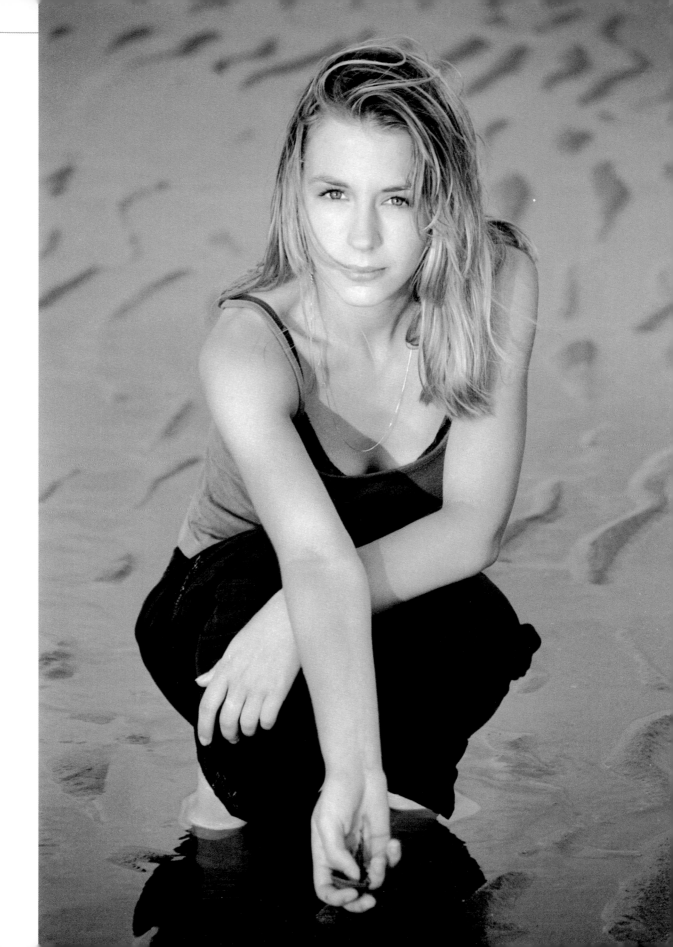

USE LATE AFTERNOON LIGHT

The quality of natural light changes from hour to hour, day to day, season to season and location to location. As a general rule of thumb, the last couple of hours before sunset generate a beautiful, soft, all-enveloping light that can be incredibly flattering to your subject. This is the time of day that many landscape photographers call the 'magic hours', as the long shadows and warm colour temperature will often transform an otherwise neutral subject. If you can get up early enough, you will often get a similar type of light first thing in the morning, but while a landscape never gets tired and grumpy, many of your human subjects will and so early-morning shoots can be somewhat counterproductive. Far better to use the late afternoon hours to bathe your subject in a golden glow that will make your portraits warm and compelling.

EVA

This shot was taken for a fashion shoot in the Caribbean. The hard equatorial sun had just begun to sink low in the sky and the shadows were softening as they crawled along the edge of the sandy beach and fell behind the palm trees. This created the perfect golden light that really showed off Eva's suntanned skin. I used a short telephoto lens to create an appealing perspective and to help throw the background pleasantly out of focus. It also allowed me to be close enough to the model to direct her without having to shout, but be far enough away not to be too intrusive.

Nikon DX, 85mm f/1.8 lens, 100 ISO, 1/250sec at f/4

Photoshop focus

- If the shadows on your model's face are a little harsh, roughly select the face with the Lasso tool, feather it and bring back some detail with the Shadow/Highlight dialog. You can apply this digital shadow recovery technique to the whole image, but here the bold, directional light helps to sculpt the contours of the model's figure. This is the advantage of digital editing – the adjustments can be far more precise and corrections applied locally without affecting the whole image.
- To help create the perfect tropical beach idyll, use the Clone tool to erase any erroneous footprints in the sand and pump up the saturation of the blue in the water.

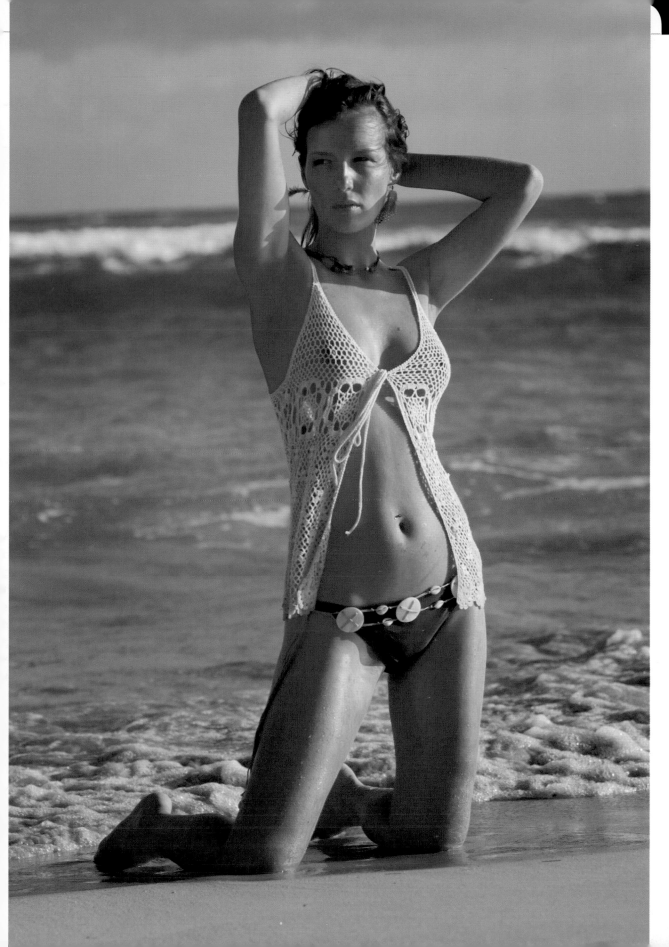

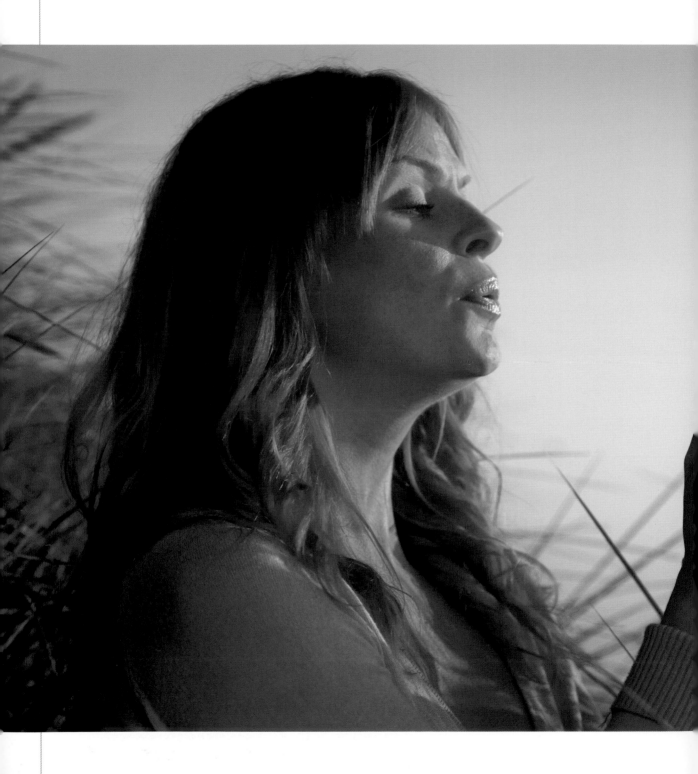

SHOOT CONTREJOUR

Contrejour (from the French for 'against the day') is a common term for backlighting, which can be a very dramatic and particularly graphic lighting technique. You can use it to silhouette your subject and give them a beautiful, almost angelic aura. Since a backlit photograph naturally casts the face in shadow, it also has the effect of softening the light that is hitting the face, making it particularly suitable for portraits. When shooting outdoors in direct sun, strong backlighting can be used to add separation from your background as it works in the same way as using a hair light in the studio. Be careful that it does not fool your camera's light meter into underexposing the image by checking the histogram on the LCD screen. If the image is underexposed, the weight of the histogram will be largely clumped to the left of the graph, which means you will have to apply exposure compensation.

ALICIA

This shot was taken at first light when the autumnal dew was still burning off under the early morning sunshine. I used a Lastolite golden reflector to bounce the light back in to the subject's face and give an overall warm feel to the image. The reflector also helped to reduce the contrast between the highlights and the shadows and allowed me to record a beautiful full-toned image and avoid a complete silhouette. I also chose a low viewpoint to isolate the subject against the blue sky and give the dandelion seeds a clean backdrop to float against.
Nikon DX, 50mm f/1.8 lens, 100 ISO, 1/1000sec at f/4.

Photoshop focus

- If you are careful with the exposure, images such as this may require little additional Photoshop work.
- Warm up the image further in the RAW converter software and use a little Fill to bring back even more shadow detail on your subject's face. This technique is similar to using the Shadow/Highlight dialog in Photoshop but works on the RAW file data and therefore optimizes the quality of the 16-bit file you are working with.
- To replicate this shot, shoot several frames and copy and paste in a few extra seeds from separate images to perfect the shape of the spray as they are being blown from the flower head.

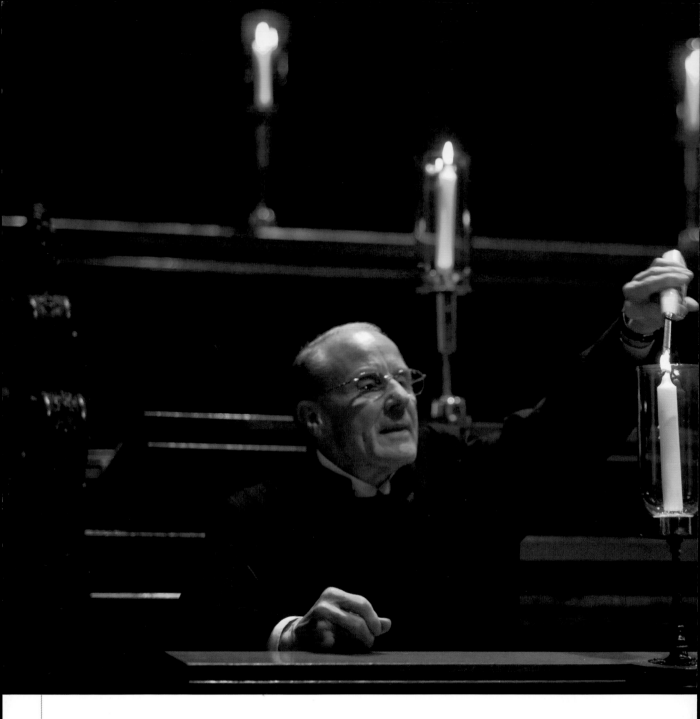

CATHEDRAL CANDLES

This shot of the verger lighting the candles for evensong at Ely Cathedral is full of atmosphere. A strong burst of on-camera flash would have ruined the mood, as it would have removed the deep natural shadows. I shot at the longer end of a standard zoom and switched the image stabilizer on, allowing me to handhold at much slower speeds. I also upped the sensitivity to 800 ISO and shot with the aperture wide open to gather as much light as possible and to further avoid camera shake. Due to the longer lens and shallow depth of field I had to choose between focusing on the verger's face or the candle. As the shot was more about his action than his face, I chose to keep just the candle sharp.

Kodak, 28–105mm f/3.5–4.5 lens at 105mm, 800 ISO, 1/8sec at f/4.5.

SHOOT IN LOW LIGHT

When the light levels start to get low, don't just pack up your camera bag and go home – work with the light rather than against it and you could be rewarded with some unusual and moody images. With modern, high-quality digital cameras and fast image-stabilizing lenses, you can produce arresting images that would have been almost impossible to obtain handheld a few years ago. Image-stabilization or vibration-reduction lenses will allow you to shoot at shutter speeds around 3 stops slower than a normal lens with a similar focal length. They also allow you the freedom to move around your subject, rather than having to be tied down in one spot to a heavy tripod, which often hinders creativity. Try to resist the temptation to reach for your flashgun, as a strong burst of unnatural light can dominate the scene and may well ruin the atmosphere. However, if you do decide to illuminate your subject with a blip of fill flash, you could try a technique called slow-sync flash. This involves setting a slow shutter speed on your camera to correspond to the available light and firing a burst of automatic flash to freeze your subject. This technique is particularly useful when your subject is moving in low light.

Photoshop focus

- Set the white balance in the RAW converter software to Daylight to give candles a lovely warm yellow glow.
- Shooting at a high ISO usually introduces unwanted noise into your images. Soften the effect of noise artefacts by clicking Filter > Noise > Reduce Noise. This is a really useful filter but it requires a little experimentation to obtain the best results on each individual image.
- Pump up the colour saturation to give low-light shots a more colourful feel.

USE MIXED LIGHT SOURCES

Digital cameras are sensitive to the colour temperature of different light sources in much the same way that film is. However, you don't always have to shoot images with your camera set to basic Auto White Balance to get the most effective results. Sometimes you can add atmosphere by shooting with the camera's white balance set to Daylight and mixing in supplementary artificial light sources that will warm up the image and add their own effects. Tungsten, halogen and sodium vapour lighting burns at a much lower colour temperature than daylight, so by adding these light sources to an image that is largely lit by daylight, you will get a slightly warmer shot, demonstrating strong atmosphere and mood. Digital cameras are more flexible than film, as the prevailing light source can simply be dialled in and the white balance set in-camera or tweaked in the RAW converter software. This means that the colour temperature can be customized to each individual image, rather then having to use special films, complicated colour temperature meters and colour-compensating filters. One point to note is that fluorescent lighting tends to burn with an unpleasant green tint, which looks unattractive in people photographs, so try to avoid using this in your portrait work.

RACHEL

This image was shot for the model's portfolio and, since we'd found such a great urban location, we decided to shoot some 'punky' photos and mix the light sources for added impact. The subway was a little dark but predominantly lit by ambient light with several additional sodium vapour spotlights. I chose to place Rachel underneath one of these to give some strong direction to the light hitting her face, and shot handheld with my lens wide open. By shooting in RAW, I had the option of adjusting the white balance in the converter software to get the desired effect – in this case, I set Daylight and relied upon the artificial light source to add extra warmth to the image.

Nikon, 85mm f/1.8 lens, 400 ISO, 1/125sec at f/2.

Photoshop focus

- For best results, shoot RAW files rather than JPGs when you encounter mixed light sources and tweak the colour temperature/white balance in the RAW converter software.
- If you do shoot JPGs, the final images can still be filtered in Photoshop to reduce unpleasant colour casts by creating a Photo Filter adjustment layer. Choose an orange filter such as an 85 (or LBA) to warm an image, or a blue filter such as an 80 (or LBB) to cool the image. The final effect can then be fine-tuned using the Density percentage slider.

SHOOT A SILHOUETTE

The first silhouette portraits – shadow profiles cut from black paper – were created by Etienne de Silhouette in Paris in the 16th century. They were a cheaper alternative to more traditional forms of portraiture and yet still allowed the sitter's character to be depicted. In photography, a silhouette is sometimes all that is needed to suggest an individual's personality, but because the viewer has less information to go on, they must look a little closer to glean the subject's emotions, which can add an exciting element of mystery to your pictures. When shooting silhouettes, a strong or graphic shape is always important and the outline needs to be recognizable. Exposure-wise, shooting into the sun to produce a silhouette is quite easy – you just rely upon the camera's internal meter to calculate it. However, when the sun is not actually in the shot, it may be necessary to underexpose slightly to reduce the detail in the shadows further.

SILHOUETTE
This shot of a policeman beneath a beach umbrella in the Caribbean relies upon both the silhouette effect and strong colour. I used the long 300mm end of a telephoto zoom lens to close in on this candid portrait and counted on the 1.5x sensor crop factor to produce an extra reach of 450mm. I waited until the man faced directly ahead to create a profile and then shot a few frames with varying expressions.
Nikon DX, 70–300mm f/4–5.6 lens at 300mm, 100 ISO, 1/1250sec at f/5.6.

Photoshop focus

- When shooting into the sun, the image can sometimes look a little bleached out and lacking in colour. You can add a sunset feel by creating a Photo Filter adjustment layer and choosing a warming filter (85) with a Density of around 50%.
- Digital cameras are able to capture a lot of detail – in this case in the subject's white shirt. To get a true silhouette effect, tweak the Curves (Image > Adjustments > Curves) to increase the contrast and gain the optimum result.

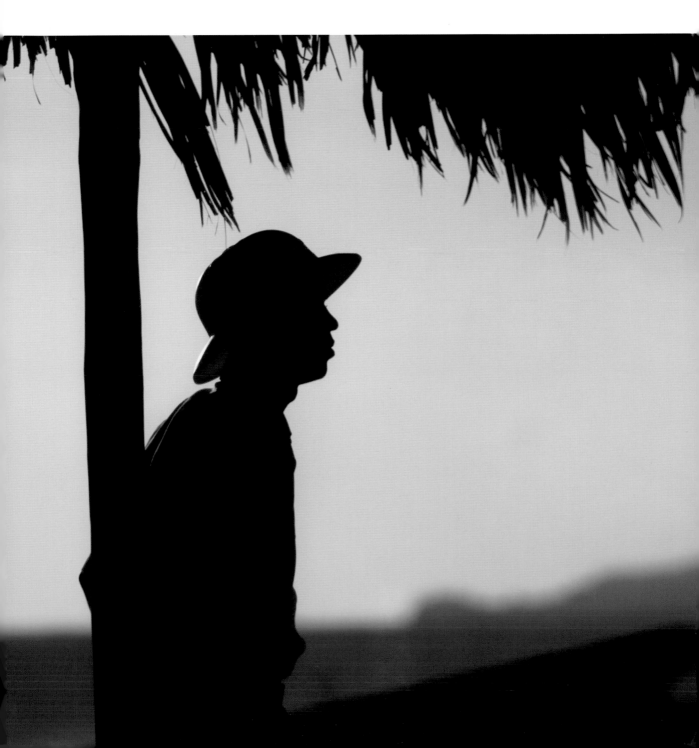

USE FILL FLASH AND FAST FLASH SYNC

One of the problems with shooting portraits outdoors is not that there is too little light, but that sometimes there is just too much. Harsh direct sunlight causes deep black shadow areas that hold little detail and creates unflattering portraits. The answer is simply to fill in the shadows with a small blip of light from your built-in flash or a hotshoe-mounted flashgun. Until recently, fill flash was a somewhat complicated technique. It was necessary to work out the correct ambient exposure and then set your on-camera flashgun to emit one or two stops less light to create a pleasing result. However, digital SLRs now do this for you automatically. Just decide upon the aperture you want for depth of field, turn the flash to Auto, and the camera will calculate the correct exposure ratio. You may find that when you want to shoot at a wide aperture, the ambient exposure is sometimes faster than your camera's maximum sync speed. For example, should you wish to shoot at f/4 in direct sunlight, your shutter speed may be around 1/1000sec – much faster than your camera's standard flash sync speed of around 1/125–1/250sec. If this is the case, switch to Fast Flash Sync or High Speed Sync and you will be able to shoot at speeds up to your maximum shutter speed while still using your flashgun.

DARCIE

This shot was taken in strong sunshine. The shadows on the girl's face, hair and dress were very deep and lacked detail due to the high contrast. I therefore mounted a flashgun on to my camera's hotshoe and filled in the shadows with a quick burst of fill flash. Since I wanted to throw the background largely out of focus I chose a wide aperture on my telephoto lens and set the camera and flashgun to High Speed Sync. This allowed me to shoot at a much faster shutter speed while maintaining creative control over the depth of field.

Canon, 70–200mm f/4 lens at 135mm, 100 ISO, 1/750sec at f/5.6.

Photoshop focus

- Clean up small marks and blemishes using the Spot Healing Brush.
- To give the image a more summery feel, increase the warmth in the RAW converter software by dialling in a higher colour temperature.
- For a more natural result, use the Clone tool to touch out the small secondary catchlights in the eyes caused by the flashgun.

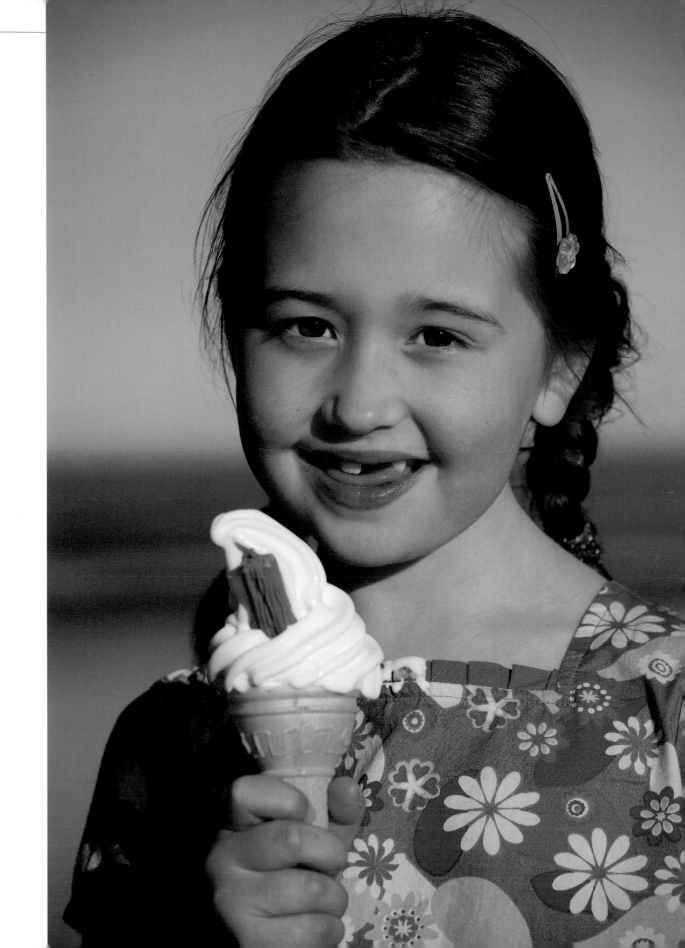

The use of ringflash extends from close-up and macro work to forensic, fashion and even portrait photography. Ringflash emits a flat, soft, all-enveloping and largely shadowless light, which is almost three-dimensional in character. This is great for images where full detail is required and where the shadows would normally get in the way – one of the main reasons it's popular with crime scene photographers. More recently, ringflash has been used in rock and pop, fashion and portrait photography because of the unique characteristics of the light that it generates. The nature of ringflash is very distinctive and it cannot easily be emulated in any other way. Because of this, it seems to go in and out of vogue, but it can always add an extra dimension to your images. Powerful ringflash used to be expensive and so was only within the reach of professional photographers. However, a more convenient and cheaper alternative is now available in the form of a RingFlash adaptor (see page 20). This relatively affordable accessory attaches to your hotshoe flashgun and gives a realistic ringflash effect.

EVA

This shot incorporates a mixture of daylight and ringflash. The late afternoon sun casts soft, warm rays from behind the model and the ringflash brightens up her face without the usual harsh directional light that is so typical of other sources of on-camera flash. The flash also breathes some life back in to her eyes by creating small catchlights.

Nikon DX, 70–200mm f/2.8 zoom lens at 200mm, 100 ISO, 1/250sec at f/5.6

Photoshop focus

- Ringflash balances the ratio of light to shadow and therefore reduces contrast, so quite often very little needs to be done in Photoshop.
- Warm up the image a little in the RAW converter software.
- Retouch any minor imperfections in the model's skin using the Clone tool.

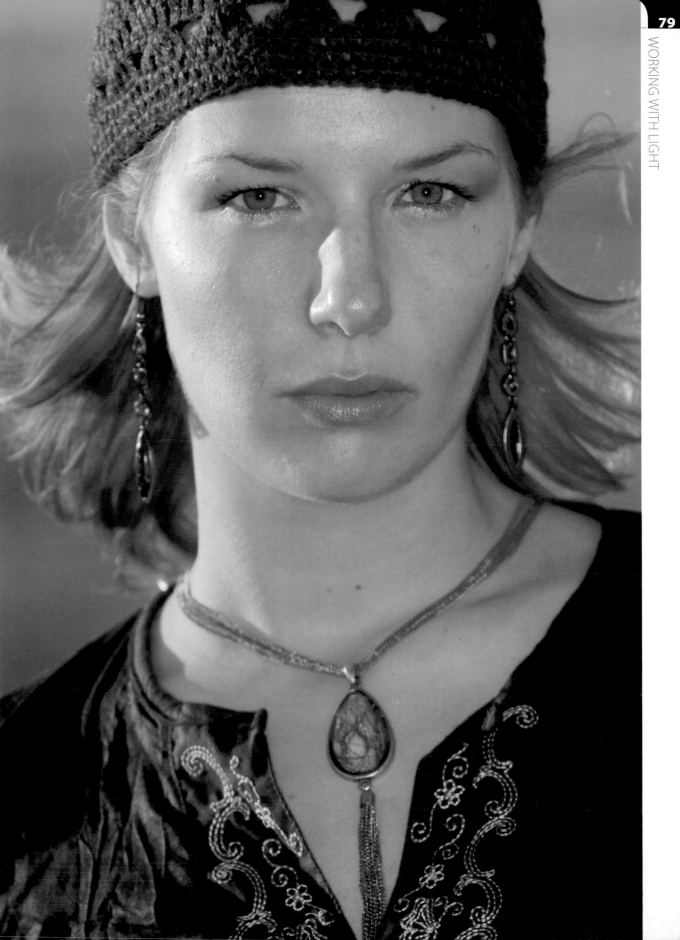

MIX FLASH
AND DAYLIGHT

While daylight in all its various forms can create a wide range of effects, mixing daylight with portable flash opens up even more creative possibilities, limited only by how much you can carry and how much you want to experiment. By varying the ratio of flash to daylight, you will be able to create almost limitless effects in your photographs. This can range from a small blip of on-camera fill flash, which just helps to lighten the shadows, to the portable and much more powerful location flash units such as the Elinchrom Ranger, which can take numerous reflectors and even softboxes. All this equipment is relatively affordable and within the reach of amateur photographers. It's not vital to have all these extra gizmos to be able to produce eye-catching photos of people, but they are fun to experiment with and will help widen your repertoire of lighting effects.

Photoshop focus

- This image was shot on colour negative film and then scanned in. When scanning film, it's important to try to retain as much information in the image as possible, and this means scanning the film with a low contrast setting that may make it look a little flat. However, once the detail is there, you can manipulate the image in Photoshop to create the result you are after.
- A slight cross-processed look helps to pump up the contrast and saturate the colour. This is easily achieved using a Curves adjustment layer and bending a slight 'S' shape in the tone curve — lightening the highlights and darkening the shadows.

CATHERINE

This image was shot for the model's portfolio. It mixes flash with ambient light at around 60 per cent flash to 40 per cent daylight. I used an off-camera flashgun with a Lastolite Ezybox Hotshoe softbox attachment to brighten up the model's face and introduce catchlights in her eyes. By underexposing the daylight slightly, the blue sky and sea has become more vivid and almost looks like a painted studio backdrop

Mamiya, 150mm leaf shutter lens, Fuji Reala 100 ASA film rated at 64 ASA, 1/250sec at f/8

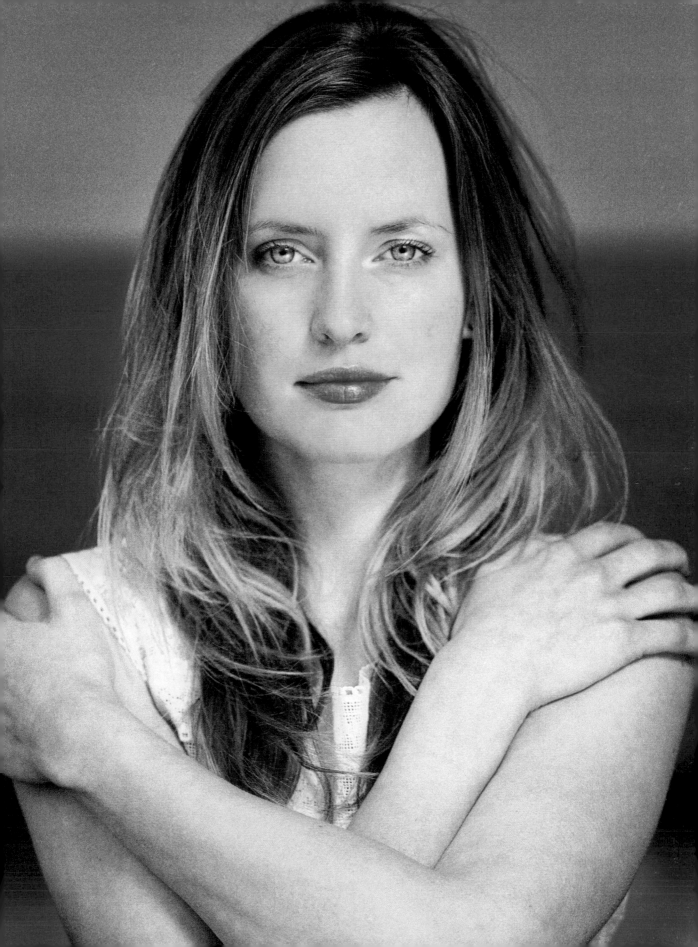

CREATE
HOME STUDIO

The cost of good-quality studio lighting equipment has fallen dramatically in recent years. This is great news for anyone wishing to practise their portrait skills indoors when the elements outside are proving to be less than favourable for location work. When thinking about creating your own home studio, the more space you can have the better, so a spare room with a high ceiling, or perhaps even a warm garage, would be ideal. Manufacturers such as Elinchrom, Bowens and Lastolite produce introductory kits that include flash units, softboxes, umbrellas and stands, and in some cases even a free instructional DVD. These kits are perfect to get you started, allowing you to keep things simple while you get to grips with the basics.

MICHELLE

This contemporary image demonstrates how just a couple of low-powered studio flash units and a little imagination can lead to striking results. I used a small Elinchrom softbox from the D-Lite 2 kit to the right of the camera and fired towards a second open head flash unit that was situated directly behind the model. This backlight caused some lens flare that has helped add mood and atmosphere to the shot. The rear light also acted as a hair light to lift the dark shades of her hair and separate it from the background.

Canon, 70–200mm f/4 zoom lens at 200mm, 100 ISO, 1/250sec at f/5.6

Photoshop focus

- Lighten and clean up the whites of your subject's eyes with the Dodge tool set to Highlights and a low Range of around 5%.
- Clean up any minor blemishes on the model's skin with the Healing Brush and Clone tool to create a perfect complexion, while taking care not to introduce an overly airbrushed appearance.
- Add a slight soft-focus effect to create a dreamy and atmospheric feel to contemporary fashion-style images.

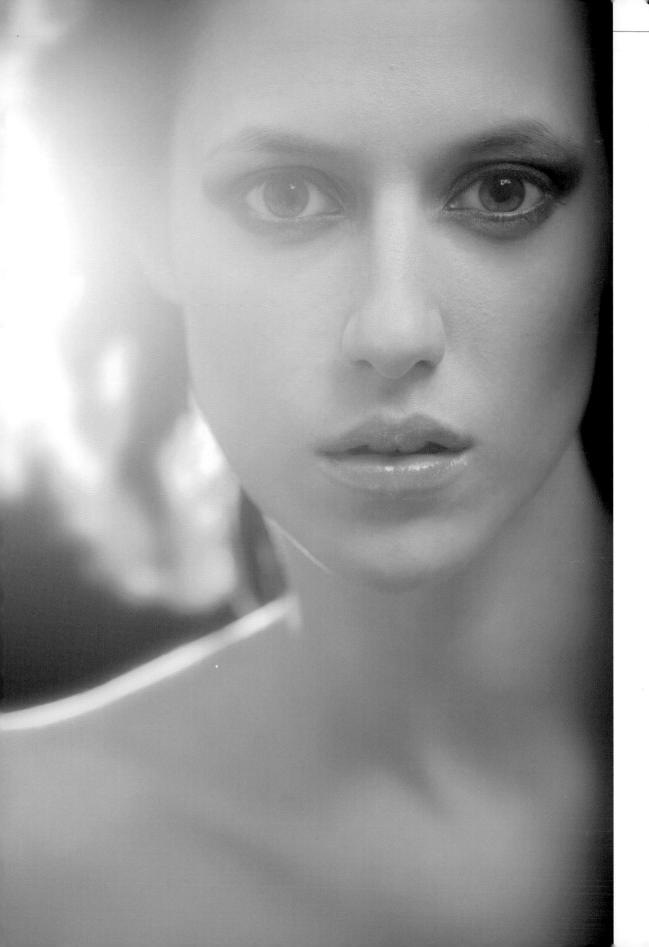

You don't need to spend a great deal of money on lighting equipment to take great portrait photos. As you have seen, natural light, in all its many shapes, qualities and forms can be used to create endless styles of images, but don't be afraid to experiment with basic and affordable studio lighting too. Many professional photographers use very complicated studio set-ups with a plethora of different lights ranging from tungsten to halogen to flash, with all their accessories and personal gizmos. However, even with a single studio light, a little imagination can go a long way. By using a simple single light source, it's possible to produce some masterly lighting effects on a shoestring.

THE PHONE CALL

This shot uses just a single low-powered Elinchrom D-Lite studio flash unit with a standard reflector. I placed the light slightly behind the model to the left and at eye level, enabling me to backlight the wisps of cigarette smoke. Using a single strong light source creates contrasty and atmospheric shadows that add drama to the simple composition. By restricting the light and carefully placing the shadows, the final result is highly effective.

Nikon DX, 85mm f/1.8 lens, 100 ISO, 1/250sec at f/2.

Photoshop focus

- Convert the image to black and white.
- Burn in around the edges to create a dramatic vignette effect.
- To further concentrate the viewer's attention on the model, blur the background ever so slightly by selecting the model, inverting the selection and applying a little Gaussian Blur.
- Add a small amount of Diffuse Glow for effect by clicking Image > Filter > Diffuse Glow.

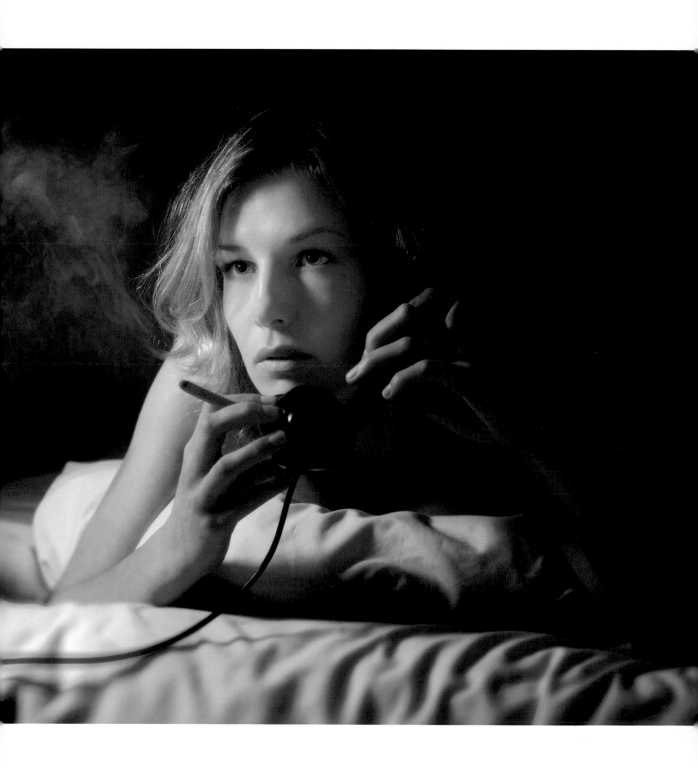

USE HARD LIGHT

More often than not, pleasing portraits are created using a large, soft lighting set-up, which, as we've seen, can be very flattering – particularly for female subjects. However, the opposite is often true when photographing men, as a harder light source may be better to show off strong masculine features. This hard light can be from an ambient source such as direct sunlight, or it can be created in the studio with various accessories, reflectors and lighting attachments. Hard lighting will emphasize shape, textures and contours, so it's great for showing off muscle definition on your subject's body and for depicting character in his face, by accentuating chiselled cheek bones and a strong jaw line.

OLIVER

This image, shot for the model's portfolio, used only one Elinchrom D-Lite studio light, which was positioned directly above and was fitted with a conical snoot attachment. The snoot concentrated the intensity of the light into a strong, narrow beam, creating definition, shape and strong symmetry to his very manly features. The hard light combined with direct eye contact produces a very bold and lucid character study that communicates the subject's strength, determination and conviction.

Mamiya, 150mm f/3.5 lens, Fuji Reala 100 ASA film, 1/60sec at f/5.6.

Photoshop focus

- Convert colour images to black and white and then select the irises of the eyes using the Lasso tool or with a Quick Mask (see pages 136–7). Duplicate the layer and colour the eyes with the Hue/Saturation dialog with the Colorize box checked.
- To simplify the design, burn in the shadows with the Burn tool and eliminate any excess detail in the background and hair.
- Whiten the subject's eyes using the Dodge tool with Range set to Highlights.

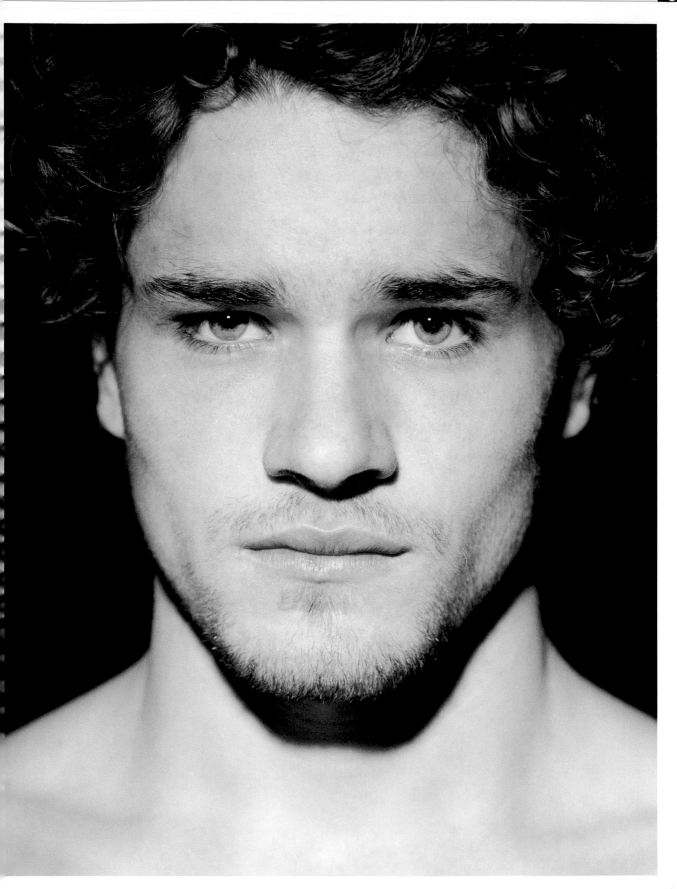

TRY A TRI-FLECTOR

This product will add real distinction to your home studio portraits. The Lastolite Tri-flector is a lightweight triple reflector that can be positioned exactly where you need it, to lighten shadows on your subject's face. When lit from above and when positioned beneath the sitter's chin, this butterfly-shaped device also has the added advantage of creating incredible half-moon catchlights in your subject's eyes, which really brings them to life. The Tri-flector also creates a soft wrap-around lighting effect that is fully adjustable and is especially flattering for female portraits. This accessory is unique in its flexibility and design, and is portable and ultra-light – making it a must-have for any budding studio photographer.

JODIE

This image consists of quite a basic lighting set-up. I placed a large softbox above the girl's head and just in front of her face and I angled this box in to the Tri-flector below. This created a wonderful directional lighting effect with soft shadows and the trademark catchlights in her eyes. I also chose to add a second light behind her and to my left, which fired straight towards her hair to bring her blonde locks to life and to separate her from the grey background. Finally, I added some movement to her hair with a large desktop fan blowing into her face for a stylish look that would not look out of place in a glossy magazine.

Kodak, 85mm f/1.8 lens, 160 ISO, 1/125sec at f/5.6.

Photoshop focus

- Shoot in RAW mode and convert to black and white.
- Whiten eyes and remove any skin imperfections with the Clone tool and Healing Brush.
- Try adding a blue tint to give images a more contemporary look by clicking Image > Adjustments > Color Balance and adding +15 blue to the midtones.

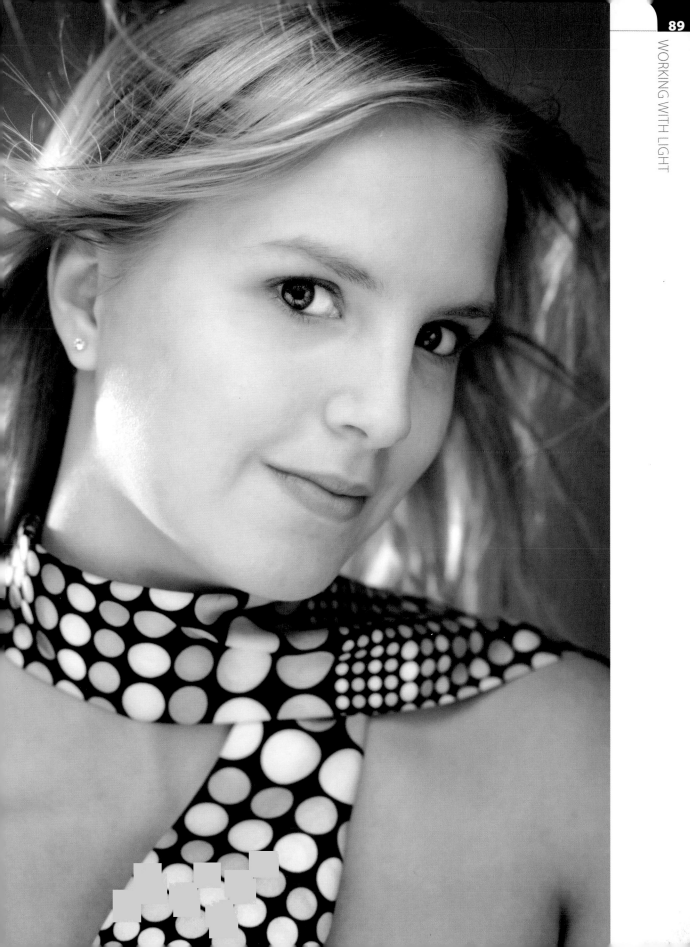

PHOTOGRAPHING PEOPLE

One of the most important skills that any portrait photographer must learn is not technical but social. Your interaction with your subjects will have an enormous impact on how well you realize your creative vision, and in many respects this ability cannot be taught. When working with people, you must always remain professional and treat them how you would like to be treated. I personally hate having my photograph taken and much prefer to be behind the camera than in front of the lens. Perhaps this gives me an advantage, as I am able to empathize with my subjects and make them feel more at ease. All people are different and they come in all shapes, sizes, characters and dispositions – it is this individuality that makes people such a fascinating subject to photograph, and portraiture such a rewarding genre to master.

Robert and Grace
To be able to capture those real and special moments that exist between your subjects, you need to be able to relax your sitters and generate a feeling of comfort and understanding. People skills are just as important as photographic ability.
Mamiya, 150mm f/3.5 lens, Fuji Reala 100 ASA film, 1/250sec at f/5.6.

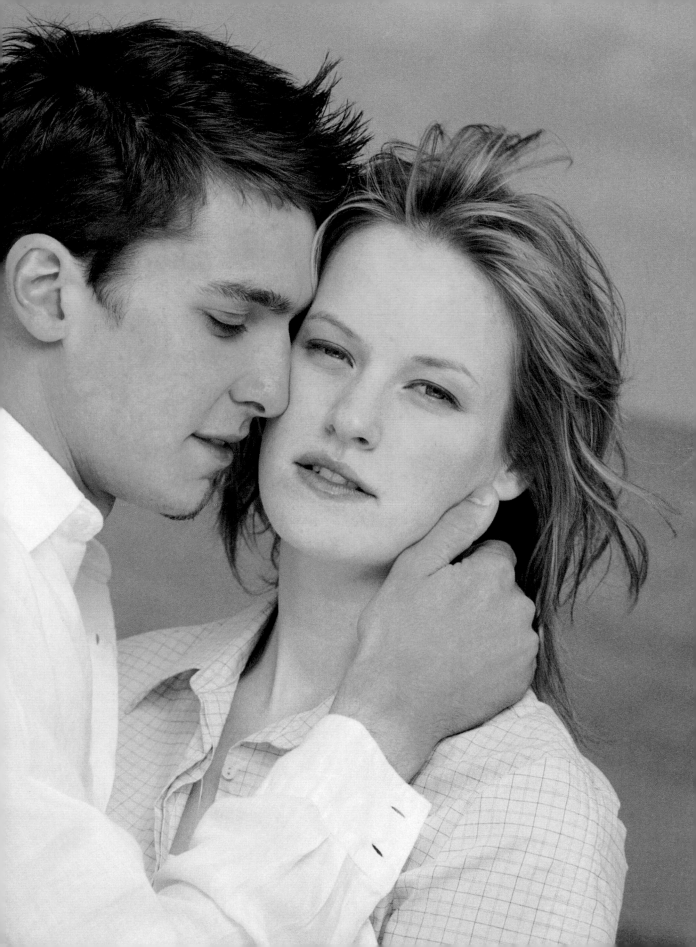

WORK WITH PROFESSIONAL MODELS

Although using a professional model is more expensive than just photographing your friends, you will find it is money well spent. Experienced models are confident in front of the camera and require far less direction than amateurs. Taking this route will mean much more professional results and you should also learn a great deal in the process. If you can't stretch to the cost of hiring an established model, try using a 'new face' from your local modelling agency. New faces are budding models who are keen to build up their own portfolio, and will accept photographic prints by means of payment. This is usually a win-win situation as they will cost little or nothing and will be as enthusiastic to create great images as you are. The agency who supply the model will also get fresh pictures for their brochure or website, all of which will lead to more work for all concerned. To achieve really first-class fashion or portfolio images you should also consider working with a make-up artist and hair stylist on a similar basis. This is the most economical way of achieving the highest quality images as well as being a key opportunity to develop your skills and confidence as a new photographer.

Photoshop focus

- With the aid of a good make-up artist, your images should require less retouching work. However, the Clone and Healing Brush tools can be used to clean up any stray hairs on faces that you didn't notice during the shoot.
- Add sparkle to eyes by lightening them with the Dodge tool.

EMILY
This portfolio image came about through teamwork. Myself, a new model, a talented stylist and an ambitious make-up artist all worked together in brainstorming ideas to produce some really strong shots. Natural light from a window was used to light the image, as well as a small reflector to bounce some light back into her face.
Canon, 85mm f/1.2 lens, 400 ISO, 1/1250sec at f/1.8.

CAPTURE FAMILY MOMENTS

Whether you're shooting photographs to share with others or just for yourself, if you can capture those special family moments, you'll be able to treasure them for a lifetime. Digital photography and new technology has made capturing perfectly exposed fleeting expressions in sharp focus easier than ever before. Modern autofocus is faster and more precise than any photographer is, and with the aid of fast frame rates, catching that decisive moment has never been so easy to achieve. Don't be frightened of shooting plenty of frames, as this type of photography is as fast-paced as any. You'll benefit from handholding the camera and moving quickly to keep up with your subject – so forget the tripod. This type of shot is best kept unstaged as this will lead to far more pleasing results, but from time to time try to catch the attention of your subjects so that you get direct eye contact, which will help communicate their emotions to the viewer.

KATE AND ELLA

This shot perfectly captures the harmony that exists between mother and child and could never have been set up. It required fast reflexes to capture, and plenty of energy to keep up with the action. I used a long 200mm lens to produce a tight crop that fills the frame and gives the photograph its full impact. There were several similar images taken within seconds, but this one stands out above the others and captures the special bond between the subjects.

Nikon, 200mm f/2.8 lens, 100 ISO, 1/1000sec at f/4.

Photoshop focus

- Perform some digital dentistry with a few quick clicks of the Clone and Dodge tools, to create the perfect pearly white smile.
- Open up the shadows in the face with the Shadow/Highlight dialog and a small Amount of around 10%.
- Add extra warmth in the RAW converter software by increasing the colour temperature slider.

SHOOT LOCAL CHARACTERS

Part of the excitement and adventure in travelling with your camera is not just the new places that you see, but also the interesting people that you will meet. These local characters will help to add a new flavour to your portfolio and offer up a whole range of new and rewarding subjects to photograph. This applies equally to your overseas adventures as to your travels closer to home. The characters that you find on your forays will all have their own personalities and will echo the cultures and influences of their locale. I always find it best to try and gain the approval of subjects before I photograph them, unless I'm after a more candid approach. Try to learn a few words from the regional dialect so you can communicate your intentions and remain courteous at all times. The final point to remember is that your own smile goes a long way towards breaking down the initial barriers of communication.

Photoshop focus

- If you are unable to throw the background out of focus in-camera, roughly select the subject in Photoshop, invert the selection and then apply some Lens Blur (Filter > Blur > Lens Blur).
- For this image, I cropped in closer and interpolated the file back to 50MB (approximately 29.7 x 42cm/11½ x 16½in at 300dpi). This will inevitably degrade the absolute resolution, but in this case it created a much better final image.
- Increase the colour saturation for added vitality.

CABALLERO

This image of a rather distinguished old Spanish gentleman was just crying out to be taken. He was sitting on a quiet bench on the edge of a busy market square, watching the world go by. His stylish yet phlegmatic manner was captured by making eye contact with the camera, but this only lasted a few seconds before his attention waned. You often only get one chance at this type of shot, so try to think about what you want before you approach your subject.

Nikon DX, 28–105mm f/3.5–4.5 zoom lens at 60mm, 200 ISO, 1/180sec at f/5.6

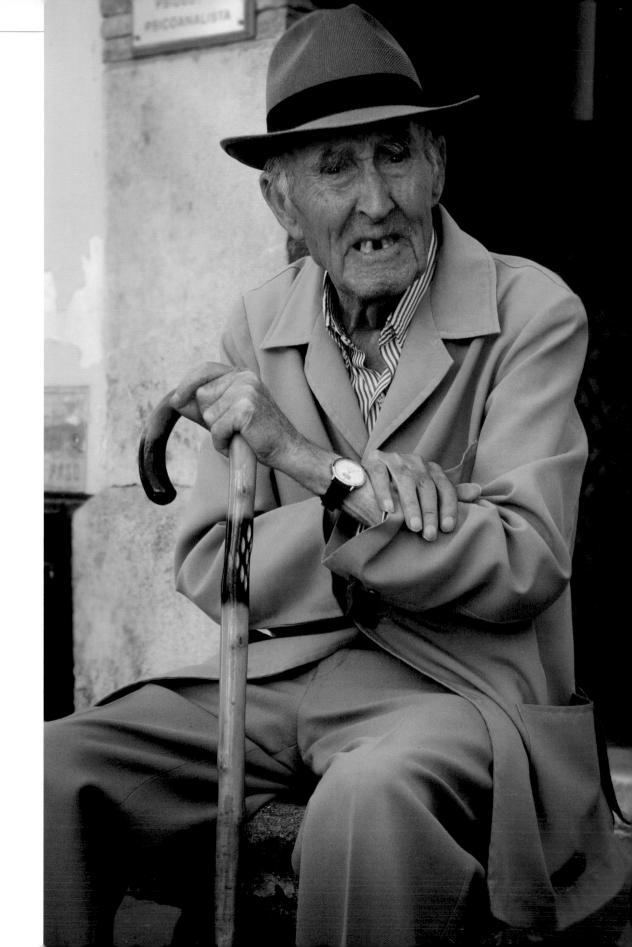

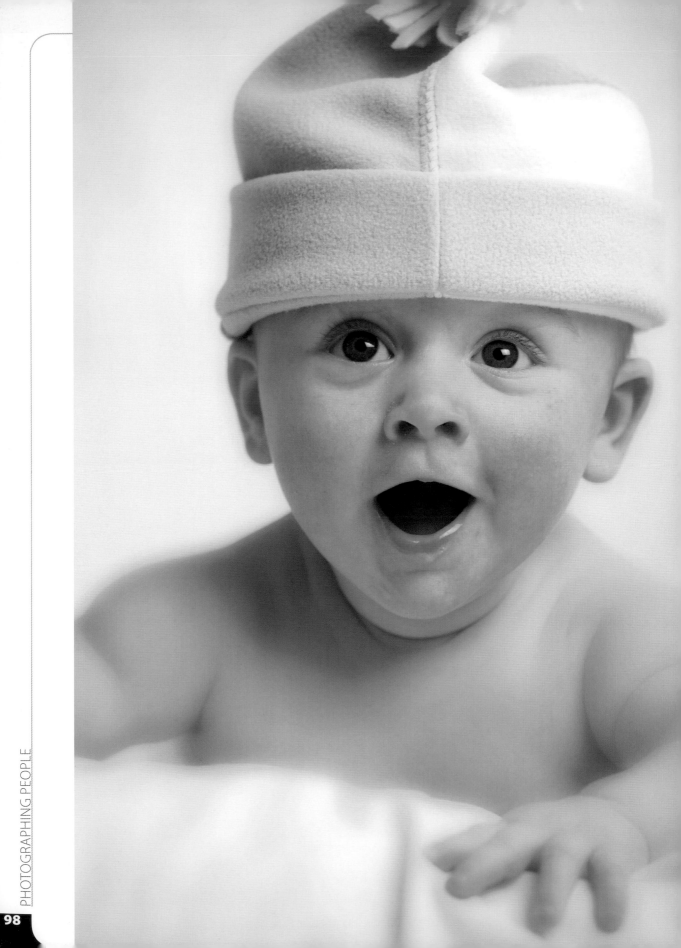

CREATE CHARACTERS WITH KIDS

Photographing kids is very entertaining, and so your pictures should try to reflect this. One of the best ways to conjure up this sense of fun is to create characters with children. With the use of props, outfits and some carefully chosen accessories, you should be able to create a recognizable theme, perhaps even imitating a famous icon or a superhero. While some people may find this approach a little too sugary, the images created should certainly have the 'Ahh' factor, and be firm favourites in the family album. This type of photography requires a sunny disposition to keep the kids smiling and the whole experience fun, as well as super-fast reactions to capture those fleeting magical moments.

ELLIS

This image of six-month-old Ellis hinges on the humorous hat and his comical appearance. The shoot was a lot of fun, with his mother amusing Ellis while I tried to capture all his different facial expressions. The result is an endearing image and a great character study. A very basic home studio set-up using just one softbox and a white sheet as a backdrop was all that was required for this shot, but it was crucial to create a warm, inviting environment for the baby to feel comfortable in.

Canon, 70–200mm f/4 zoom lens at 135mm, 100 ISO, 1/250sec at f/4.

Photoshop focus

Use the Clone tool to clean up any blemishes on the subject's face.

Add a soft-focus effect to high-key images such as this, as well as a little Diffuse Glow. Play with the settings to create the desired degree of filtration and eliminate any grain.

Reduce any hard, distracting creases beneath babies' chins with the Healing Brush on a duplicate layer at around 60% Opacity.

KEEP YOUR SUBJECT'S HANDS BUSY

When photographing non-professional models, you'll often find that your sitter will feel uncomfortable about being in front of the camera. In order for your subjects to look natural in your photographs, they must feel relaxed, and it's your job to try and achieve this. One aspect of people photography that is of frequent concern is what to do with your subject's hands. If your sitter is feeling anxious, you'll be able to read this in their body language and this in turn will be translated to your photographs. To remedy this, it's important to try to keep your sitter's hands busy and pose their body in a way that they feel comfortable with. This can sometimes mean giving your subject something to hold on to or perhaps even getting them to slip their hands into their pockets. By doing this, your subject will feel more at ease and the resulting images will look far more genuine.

ERIC

This photograph of a sea fisherman standing in his old wooden boat is a fine example of this technique in action. He felt awkward about having his picture taken, and too considerable persuading to allow me to shoot him, but the weathered character in hi face was too appealing to resist capturing. After a few minutes of conversation to brea the ice, I positioned him inside his boat and got him to rest his hands on the side. Thi gave him a far more relaxed demeanour and his almost heroic stance rewarded me with a definitive character study

Mamiya, 55mm f/2.8 lens, Kodak T-Max 100 ASA film, 1/30sec at f/5.6

Photoshop focus

- This image was shot on film, then scanned to retain full detail from the shadow areas to the bright highlights in the sky.
- Convert to black and white and add a sepia tone to give a timeless effect.
- To add drama to skies, burn in the sky with the Burn tool with the Highlights set to around 20%.
- To bring out more detail in faces, lighten the midtones using the Dodge tool.

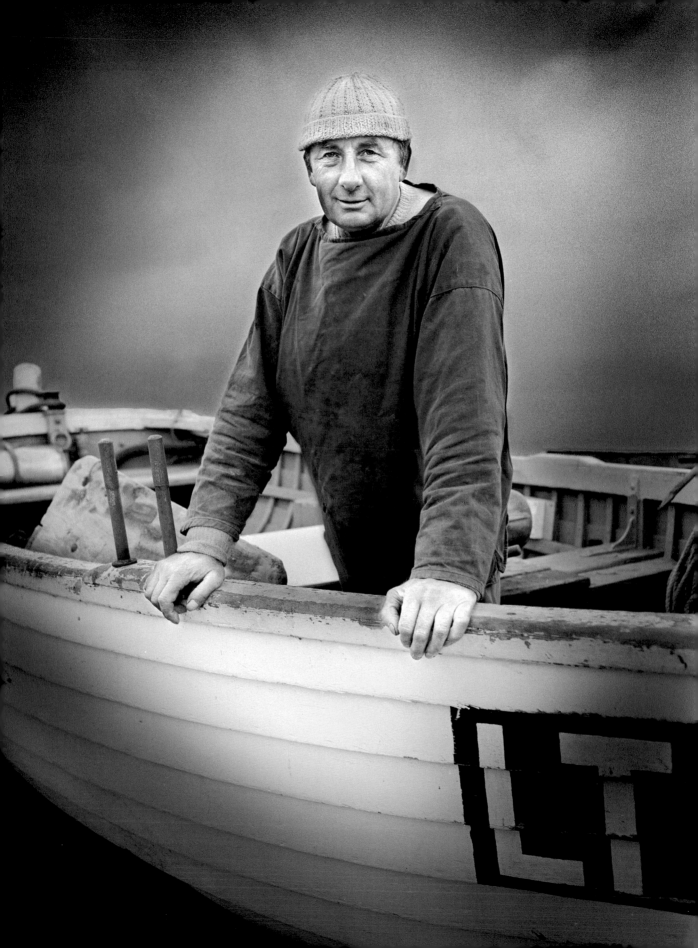

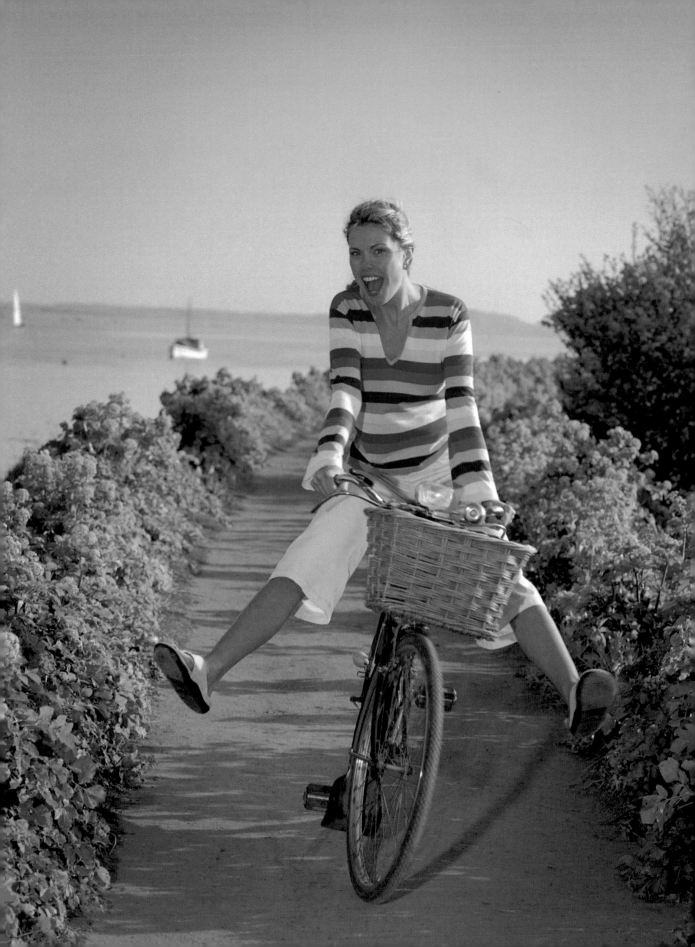

INTRODUCE ACTION TO YOUR IMAGES

It's often all too easy to produce people images that can look a little static and frozen, so why not try to introduce some action to your images? Giving your subject something physical to do rather than just standing and posing will help them feel more involved and will add a sense of fun to the whole shoot. By capturing some movement in your photographs, you will also be able to produce images with more dynamism and greater energy. When selecting a suitable shutter speed to capture this movement, you will lose some control over depth of field, so it's often a matter of juggling the aperture settings to achieve a result you are happy with.

JODIE

This image was shot for a magazine cover and demonstrates how some action can really bring the photograph alive. I asked Jodie to pedal slowly along the path and then take her feet off the pedals and coast towards me. Her expression of humour and enjoyment were captured perfectly in that brief moment when I tripped the shutter. As the location also played an important part in the image, the smaller aperture setting balanced with a slow shutter speed helped to convey the mood I wanted. I also added a little fill flash to brighten up the colours and soften the shadows.

Mamiya, 150mm f/3.5 lens, 100 ISO, 1/30sec at f/16.

Photoshop focus

- Pump up the colour saturation for an even more dynamic image.
- If your image is slightly backlit, as this is, try adding a mild graduated blue effect to the sky with the Gradient tool set to an Opacity of around 20%.

CREATE ENVIRONMENTAL PORTRAITS

Environmental portraits are photographs of people in their normal place of work, rest or play. Including the location in your image will help put your subject in context, reflecting their life and illustrating their unique story. This type of portrait will often give a much deeper insight into the personality, skills and character of your subject and will demonstrate the complex relationship that exists between them and their surroundings. When shooting an environmental study, try to spend some time getting to know your subject. Use this opportunity to learn who they are, what they do and exactly why the location is important to them. This familiarity will inevitably lead to a greater understanding of your sitter, which will help you to create a definitive portrait of them. In addition, once you show more interest in your subject, your subject will show more interest in you and the camera.

NIB

I fell upon Nib by chance. I was exploring the Lincolnshire Fens, looking for images for my portfolio when I came across this intriguing location. The old tractor-breakers yard echoed all that was important about this region, with its strong ties to farming. This old guy appeared, conversation started and I soon realized what a wonderful subject he would make. At first he was reluctant; he couldn't understand why I found him so interesting and why I would want to take his portrait. A little flattery went a long way and eventually he agreed to a few frames. I sat him where he felt most comfortable; he lit his Woodbine cigarette, and just watched me. I used a wide-angle lens to capture him in context with his surroundings and fired off a handful of shots before his attention drifted and the moment was past.

Mamiya, 55mm f/2.8 lens, Kodak T-Max 100 ASA film rated at 50 ASA, 1/15sec at f/8.

Photoshop focus

- The original film image was shot on slow black and white film and scanned to generate a super high-resolution digital file.
- To add depth to the photograph and to spotlight the sitter, heavily burn in the image around the edges using the Burn tool.
- A sepia tone effect can be added to give a vintage feel to the image.

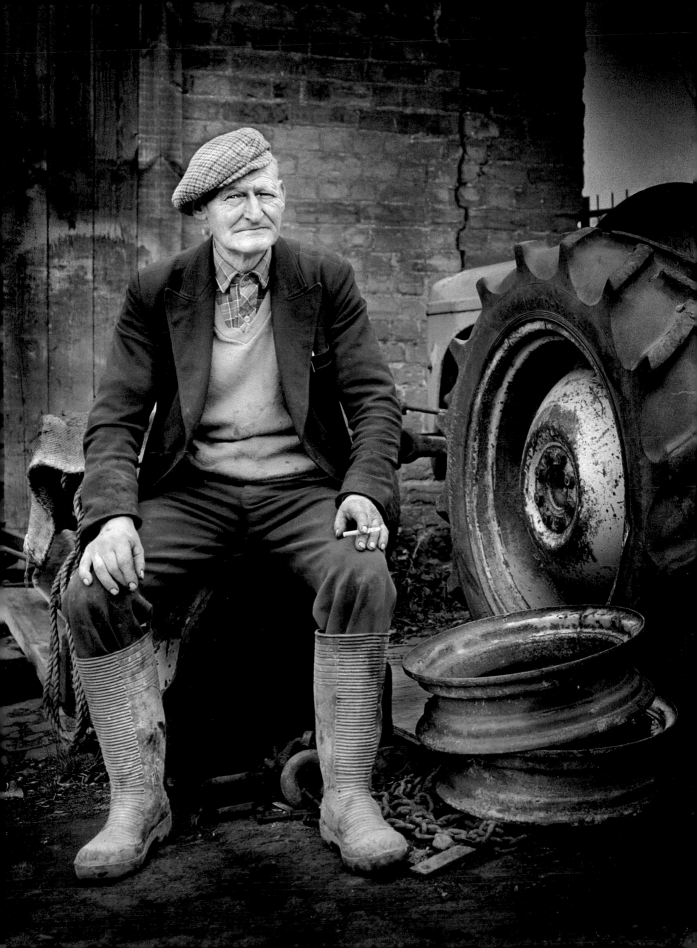

CAPTURE CANDID
MOMENTS

Sometimes the very best photographs require little organization; this is especially true when capturing candid images of children. Recording those special moments from a distance can lead to very natural photographs that will look great in your family album. As your subjects will be largely unaware of the camera, the expressions you capture will be uncontrived and will catch your subjects in a completely relaxed frame of mind. Since you will largely be adopting a fly-on-the-wall approach, you don't really need to guide your subjects; just stand back and allow those candid moments to develop. The less involvement you have, the more spontaneous the results will be, but you'll need to have fast reflexes and the energy to move quickly to successfully capture them when they do. The real secret is to allow your subjects to be distracted from the whole picture-taking process and just let them get on with whatever they are doing.

CHLOE AND ELLIE

This shot of two sisters sharing a moment of laughter has a wonderfully candid feel, as it's completely unrehearsed. The girls knew I was there but they were so involved with each other that they were blissfully unaware of what was going on around them. This sort of image often benefits from being taken with a slightly longer lens, as it will allow you to keep a greater distance and be less intrusive. Moments like this only last for a fraction of a second so you need to be ready for them, with your trigger finger on the shutter button. Canon, 70–200mm f/4 lens at 200mm, 100 ISO, 1/500sec at f/5.6.

Photoshop focus

- Capture things right in-camera and very little computer work will be needed.
- Add a little warmth in the RAW converter software to give your shots a more summery feel. If your image is backlit, as this is, dial in some highlight recovery to hold some additional detail in the skin tones while opening up the shadows with the Fill slider.

POSE YOUR SUBJECT

There isn't a right way or a wrong way to pose your model, but there is a way that is appropriate to your subject and to the purpose of the shot. For example, glossy fashion magazines often feature models posed in awkward positions that look very unnatural, but the images still work for their end use. The photographers are perhaps trying to convey a bold or daring statement about their subject and the clothing that they are wearing. However, posing a distinguished old lady in a similar fashion would be inappropriate. Conventional and more staid poses may look just that – too conventional and staid – so for a more contemporary look use your imagination to come up with a more unusual pose. In addition, you can also use posing as a technique to hide, accentuate or sometimes flatter your subject's physical appearance. If you're photographing a body builder with a fine, toned physique, it wouldn't be right to pose him in a feminine manner, but you should use his assets in a way that emphasizes his strength and power … unless of course, you are trying to convey his more sensitive side. Whatever pose you decide on, it should reflect the subject's character and aid the overall message behind your image.

JOE

This is a very masculine pose that accentuates the model's good looks, and the eye contact delivers a firm and direct message. Using his bare arms to frame his face, the viewer's attention is directed straight to his features, and the imaginative pose brings a creative feel to the image. It was necessary to get Joe to try several different poses until we had achieved the right look. I found the LCD screen was perfect for communicating these ideas to Joe and aided the process enormously.

Canon, 70–200mm f/4 lens at 150mm, 100 ISO, 1/250sec at f/5.6.

Photoshop focus

- Convert images from colour to mono using a Black & White adjustment layer (Layer > New Adjustment Layer > Black & White). Here the Preset was set to Green.
- Use the Burn tool with a large brush and a small Exposure of around 10% to burn in the highlights in the frame, which will help concentrate the viewer's attention on the face.
- Add a warm sepia tone by creating a Color Balance adjustment layer (Layer > New Adjustment Layer > Color Balance) and then dial in a small degree of red and yellow to the midtones and shadows.

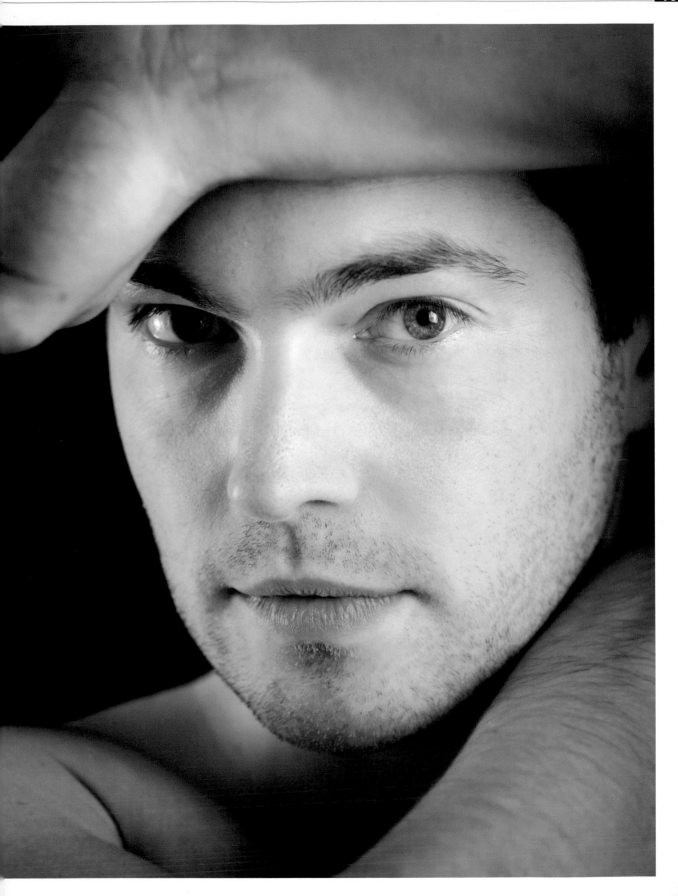

USE PROPS TO TELL A STORY

The use of appropriate props in your people photographs will help to strengthen your creative message and illustrate the story of your sitter. Props can also help to give some comfort to your subject and make them feel more relaxed in their own environment, occupying their mind and body, and giving them a sense of purpose. This can only lead to more credible character studies and ultimately better images. For successful photographs, it's very important to consider what your subject is wearing and whether the clothing is appropriate to the overall story you want to tell. Don't forget that everything in the photograph will need to support your statement, so paying attention to even the smallest details is important.

Photoshop focus

- If shooting on a relatively dull day, warm up the image in the RAW converter software by setting the white balance to Cloudy.
- Introduce some extra colour by pumping up the saturation.
- To emphasize the subject, burn in the background a little with the Burn tool to set 20%.

ROBERT

I spotted this old shepherd and his sheep dog as two smal figures silhouetted against the skyline as I was driving through the rolling hills of northern England. As you gain experience as a photographer, your eye will become so finely tuned in tha you can spot a potential image in just a fraction of a second and even at a great distance – almost like an eagle picks out its prey. stopped the car and ran up the hillside with my camera and zoom lens slung over my shoulder. After getting over his initial surprise and after a few minutes of conversation, I positioned him with his dog and walking stick against one of the dry-stone walls that are so typical of this region. His weathered face, old flat cap and worr clothes all add to the feel of the image and help to portray thi traditional man in his natural surroundings

Kodak, 70–200mm f/2.8 zoom lens at 200mm, 160 ISO, 1/250sec at f/4

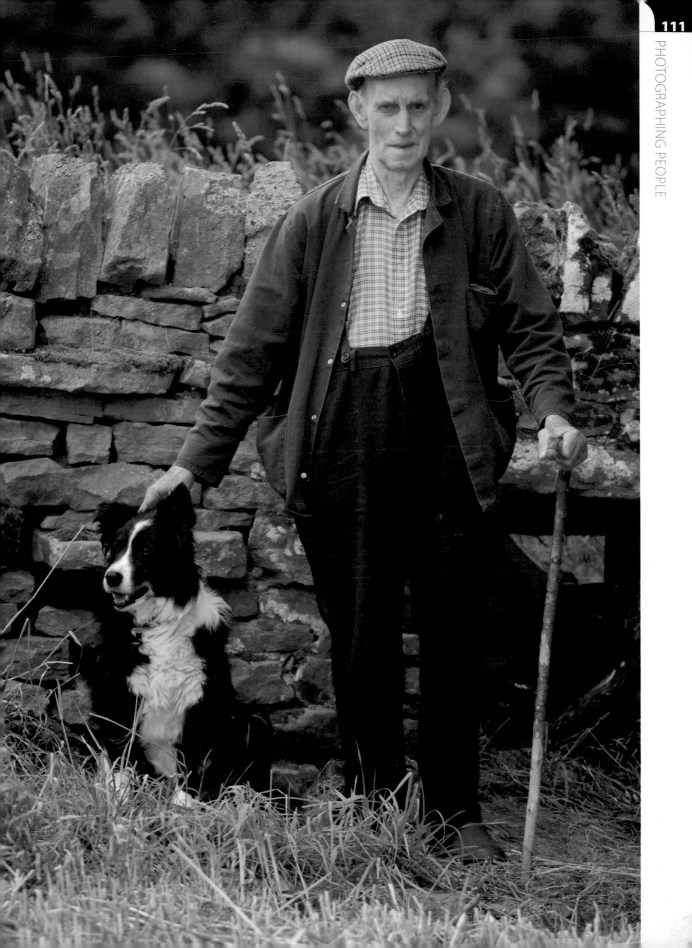

CAPTURE CHILDHOOD INNOCENCE

Kids are among the most fascinating, endearing and rewarding subjects to photograph. If you are patient and have the temperament of a saint, their innocence, vitality, charisma and charm can lead to some genuinely emotive imagery. If they are your own offspring, even better – they will be less shy in front of your camera than they would be in front of even the best professional photographer. You will also have the advantage of knowing how to get the best reactions from your own children, what interests them the most and, more importantly, what bores them the quickest. You will often find that younger kids have not developed any anxiety towards the camera, as they don't yet fully understand what it is. This naivety can lead to very natural pictures, as they have few inhibitions and the expressions you'll capture (if you're quick enough) will be genuine and unposed. The resulting images should be justly rewarding and record those precious childhood moments for generations to come.

MACKENZIE

This is another shot of young Mackenzie enjoying herself at the beach. For children, the seaside can provide an endless opportunity for fun, learning and excitement, so it's always a great location to work in. I spent a couple of hours chasing her around the rock pools with my camera as she amused herself and explored a whole new world of nature. I used a telephoto zoom lens to conveniently alter the crop in each situation and save myself a little legwork, making keeping up with her a little easier. This shot was taken as she kindly offered me a shell from the beach. Moments later, she dropped it in my open camera bag full of expensive equipment along with a large handful of sand … thank you so much

Nikon, 70–300mm f/4–5.6 lens at 250mm, 200 ISO, 1/250sec at f//8

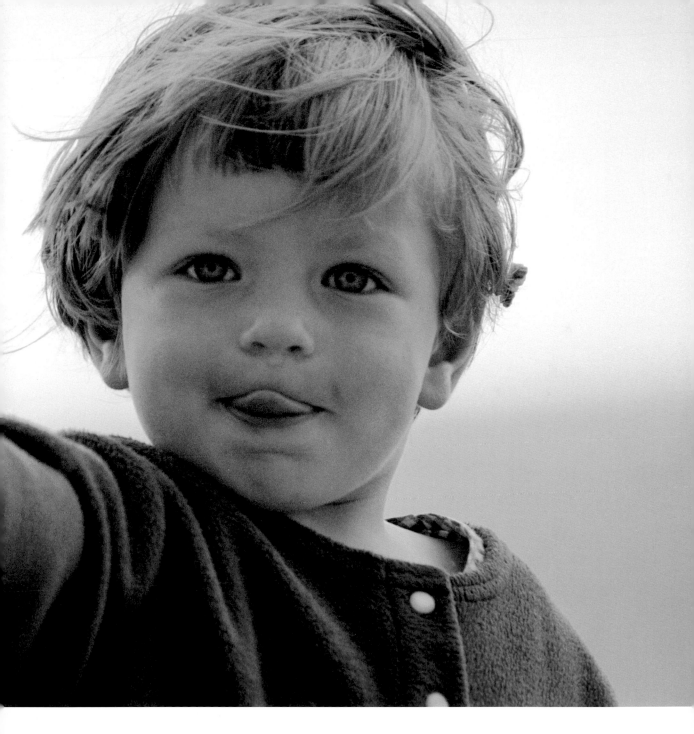

Photoshop focus

Capturing the image just right in-camera means very little Photoshop work is needed.
Convert the RAW file from colour to black and white and then split tone it using Image >
Adjustments > Color Balance.
Lighten the midtones on the subject's face with the Dodge tool set to a small Exposure
of around 10%.

CREATE A BOND BETWEEN YOUR SUBJECTS

When photographing two people together, it's all too easy to create a tension between your subjects, especially if they don't know each other very well. This awkwardness needs to be overcome, because if the subjects feel uneasy, they will look uncomfortable in the final image. To get your subjects to relax, allow them a little time to chat while you prepare. As they get to know each other, they will hopefully lose their shyness, become more spontaneous and begin to bond. If the subjects are already familiar then your job is easier – try to take advantage of the relationship that exists between them. This sometimes means moving them together so they are physically close – perhaps holding hands or embracing. Whatever way you choose to link your subjects, if you can create an obvious connection then the photograph will convey a strong message, and your picture will be far more successful.

NICK AND BETH

The models in this image had never met before and this was their first real photo shoot – making the situation doubly tricky. However, after a few jokes to break the ice they genuinely started to enjoy themselves. I'd already got a strong idea in my mind's eye of what I wanted compositionally, so it was merely a case of communicating my ideas and positioning them together to create the vision. Sometimes, rather than capturing your subject laughing or smiling, it may be appropriate to create more of a sense of ambiguity or enigma. This can force the sitter to ask themselves more questions about the subject and can lead to a more intriguing image. After all, if we all knew what the Mona Lisa was thinking, she wouldn't have captivated our imaginations for so many years.

Nikon, 85mm f/1.8 lens, Fuji Reala 100 ASA film rated at 64 ASA, 1/500sec at f/4.

Photoshop focus

- The original image was shot on 35mm colour film that was down-rated for a little more shadow detail. It was then scanned on a desktop scanner at 4,800dpi to create a massive 170MB 16-bit file.
- Convert colour to black and white and then dodge and burn to darken certain areas and lighten others. Darkening eyelids with the Burn tool can help to accentuate eye make-up.
- Tone your image with a blue tone to give it a contemporary feel.

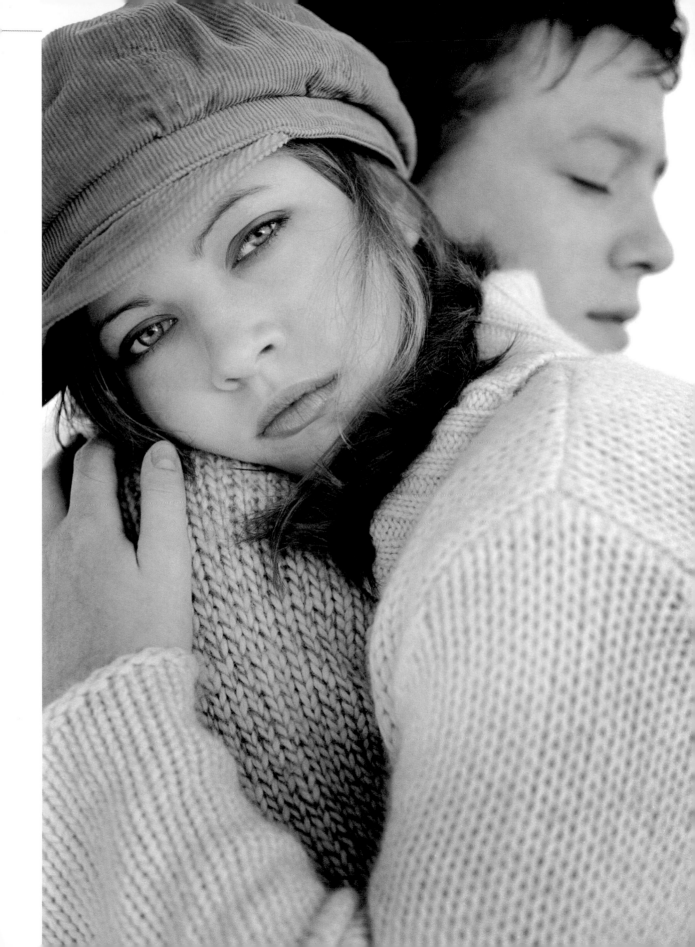

SHOOT FUNNY FACES

It is usually the photographer's job to try to capture a flattering portrait, using imagination and knowledge of light and composition to portray the subject in a pleasing way, and in a manner that also inspires the viewer. However, as with all genres of art, sometimes it's fun to break the traditional rules and aesthetics and take a different path. So, why not try and create a less flattering shot that evokes an emotional response in the viewer in a more unusual way? This can be a great technique to employ when photographing children or subjects who are a little camera-shy and feel uncomfortable in front of the lens. By adding some humour to the portrait session, you may find that it helps to break down any tension and formality and will create a more relaxed and spontaneous photograph. At the very least, it will add some fun to the situation, which will make it more enjoyable, resulting in better pictures.

ALEX

This image of a 'gurner' was taken for a personal portfolio project. It clearly illustrates the point that funny faces can be more eye-catching than adopting a standard approach. Unflattering portraits are not the norm, but by taking a more unorthodox route I've been able to capture a visually strong photograph that embodies both the sitter's character and his unique and individual talent. The horse brace around his neck has been used for many years in the annual World Gurning Championship at the Egremont Crab Fair to frame the face of the competing 'gurner', and is a tradition that dates back hundreds of years. I asked Alex to pull his best 'gurn' and a real life Popeye appeared before me, producing a captivating and humorous image that is a far cry from a flattering portrayal.

Canon, 85mm f/1.2 lens, ISO 200, 1/125sec at f/5.6.

Photoshop focus

Convert your image to mono using a Black & White adjustment layer with a Green preset. When happy, flatten the image and add a split-tone sepia effect with the Color Balance sliders; here the Midtones were set to +5 Red, −5 Magenta and −10 Yellow. Use the Burn tool set to Shadows with an Exposure of around 10% to darken the edges of the image and bring out the face of the subject.

CAPTURE GROUPS

Photographing groups of people, such as whole families, is one of the most difficult portrait situations you will probably encounter. The task is made even harder when you are including small children who have short attention spans and who do not fully understand the concept of creating a pleasing family photograph. When shooting a group, the aim is to generate a nice portrait of each individual, all at the same time. This is not an easy skill to master and the more people in the shot, the tougher this becomes. Holding the attention of each of your subjects is paramount – if only for the split second of the exposure. The picture needs to be taken quickly if the image is to remain fresh and not show signs of boredom in any of your sitters. To create a pleasing composition you need to unite all the individuals into a group formation that holds the image together visually as well as emotionally and aesthetically. Good group portraits will separate an amateur from a true professional and will require your best organizational skills as well as photographic proficiency. Ensure you are familiar with your equipment, as if you get confused and lose your train of thought, everyone else will do too and you'll be in danger of spoiling the whole shot. Finally, try to maintain an upbeat atmosphere to your session. This will help to boost morale and keep everyone in the right frame of mind.

FAMILY PORTRAIT

In this image three generations are united in a special moment. The picture captures the close family bond, as well as the characters of each of the individuals. I worked with all the family members separately first to gain their confidence and willingness to work with me and to put them at ease in front of my camera. Once I had achieved this, I placed them in an appealing formation and asked the grandfather to place his arm around his wife to establish a bond between them. As the image was primarily backlit by a setting sun and I wanted to introduce catchlights to the subjects' eyes, I had to use a tripod, so that I had a spare hand to hold a Lastolite Tri-Grip reflector to bounce the light back into their faces. When everything was set, I asked the adults to smile and then it was just a case of getting a genuine smile from the toddler.
Canon, 85mm f/1.2 lens, 200 ISO, 1/20sec at f/8.

Photoshop focus

- Warm up the image in the RAW converter software to add a pleasing glow that is concordant with late afternoon light.
- Pull out extra detail in the shadow areas using the Shadow/Highlight dialog with the Shadows set to around 10%.
- Retouch each of the individual's faces using the Clone and Healing Brush tools to make the perfect family portrait.

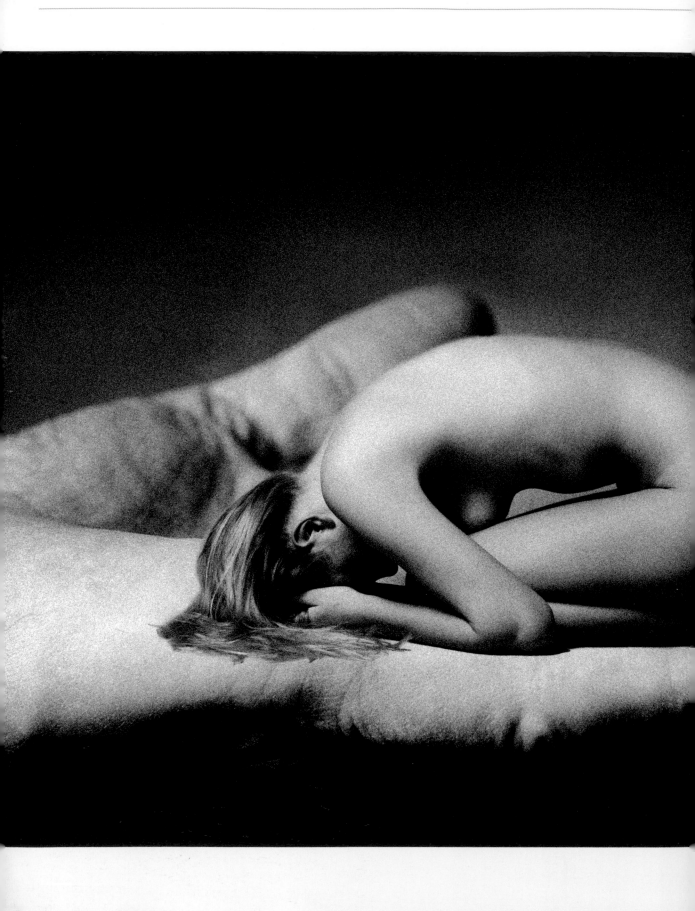

TOP TEN PHOTOSHOP TECHNIQUES

Since the release of the first version of Photoshop in 1990, photographers have been able to use digital manipulation to improve their images. With portrait photography, this has been particularly beneficial to both the photographer and the sitter, as the idea of looking a few years younger, a little slimmer or just more beautiful is very appealing. This type of digital retouching, or 'airbrushing', as it's widely known, was once used only for images of Hollywood film stars, but now, with a little knowledge and practice, you too will be able to achieve professional results that will transform your images forever. Over the next few pages, you'll learn ten very useful yet simple digital techniques that will help to enhance your portraits. As with all Photoshop tips, remember that these manipulations can easily be overdone, so try to use the techniques with a little restraint, common sense and good taste.

Nude

Software packages such as Adobe Photoshop and Adobe Elements have opened up a whole new world of creative opportunities, limited only by your imagination.

Mamiya, 150mm f/3.5 lens, Kodak T-Max 100 ASA film, 1/60sec at f/8.

TECHNIQUE 1: ELIMINATE BLEMISHES

Removing blemishes such as spots, scars or freckles is one of the easiest digital techniques you can learn to drastically improve the appearance of your sitter. This technique relies heavily on the Clone and Healing Brush tools, so it's important to master these tools properly to produce professional results.

Step 1

The teenager in this portrait has somewhat 'problem' skin with a number of spots and blemishes that could greatly benefit from some nimble mouse work using a combination of the Clone and Healing Brush tools.

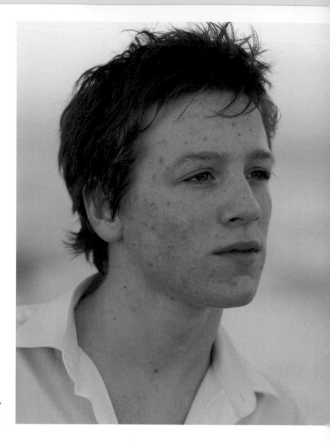

Original image
The initial portrait before any retouching work.

The Clone tool – top tips

- Always enlarge the image you are working on to at least 100% (if not 200%) to allow you to edit very specific areas at one time and to ensure you make really accurate cloning strokes.
- The Master Diameter and Hardness of the brush can be adjusted. If you want hard edges, set a higher Hardness and beware that repeated use of a soft-edged brush can lead to unpleasant blurring on your image.
- Play around with the tool's Opacity and the Flow settings, which allow you to gradually build up the final results – helpful when doing delicate retouching work.
- The Aligned box should normally be checked, but if you prefer to sample from one specific area of your image a number of times, uncheck this option.
- The Sample setting allows you to choose which layer you sample from and gives you the more advanced option of sampling from other layers should you wish to do so – this can also include adjustment layers by toggling the button.

Step 2

To make the retouching work as perfect as possible, work on the image at no less than actual size, so you can really see what you are doing. This way you can be sure how it will appear in the final print. Select your brush diameter depending upon the resolution of the image and try a brush of medium hardness (50%) to begin with.

Screengrab at 100% magnification
Make sure that you can see the exact effect of your cloning and healing – work at any less than actual size and you may unknowingly introduce cloning errors that will be visible to the viewer.

The Healing Brush tool – top tips

- The Healing Brush matches the texture, colour, transparency and lighting/shading of the sampled area and should blend the retouched area seamlessly. This often makes it a better tool for the job of retouching skin blemishes than the Clone tool.
- The Mode menu should usually be set to Normal. However, if you are using a soft-edged brush, you can set the menu to Replace to preserve the texture, noise or film grain at the brushstroke edges. This should avoid too much edge blurring on your retouched image.
- The Source option should normally be set, as the Pattern option is not very useful for retouching individual skin textures.
- The Aligned box should normally be checked, but can be unchecked in a similar way to when using the Clone tool (see opposite).
- The Sample setting gives you the option to choose exactly which layer you sample from if your image has duplicate or adjustment layers.
- The Patch tool is also under the same menu as the Healing Brush and they work in very similar ways. However, with the Patch tool you can manually sample a larger, non-circular area with your mouse and then drag it to the required position to replace the original area.
- The Spot Healing tool in Photoshop is similar to the other tools, but instead of you choosing which area to sample from, the tool automatically samples from nearby pixels and retouches the area for you. The Proximity Match and Create Texture menu settings give you more options.

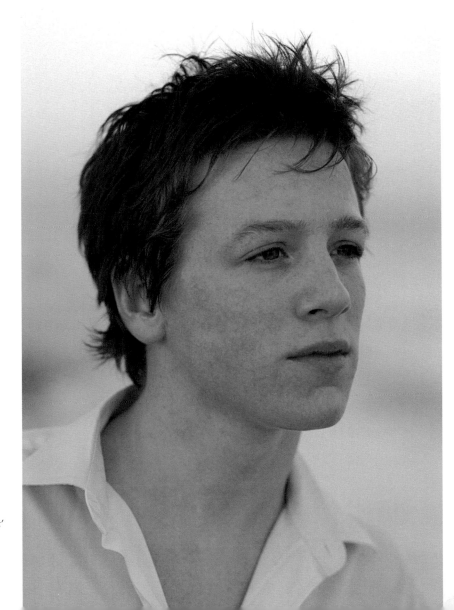

Final image after retouching
Once the work has been completed, your subject will be delighted. Just a few minutes' work with your mouse and Nick is left with a near-perfect complexion.

TECHNIQUE 2:
REMOVE WRINKLES

Photoshop makes it easy for you to make your subjects look younger and more beautiful with the aid of a digital facelift. It costs little, takes just a few minutes to achieve and, unlike real-life cosmetic surgery, is completely painless! This technique will work wonders for your reputation, and all your friends and family will want you to photograph them. This is an extremely simple and effective digital skill to learn, and can easily be mastered with the aid of layers.

Step 1

Having selected the image you wish to work on, you must first duplicate the background layer to create a copy layer. Do this by clicking through Layer > Duplicate Layer. Call this layer 'Wrinkles'.

Step 2

Now for the fun bit … using the Clone tool and Healing Brush (see Technique 1), slowly and carefully remove all the wrinkles, lines and black bags from under your subject's eyes and other areas of their face. At this stage, don't be worried that all this retouching is producing an unnatural effect, as this is just the first part of the digital facelift.

Screengrab of 'Wrinkles' layer at 100% Opacity
As you can see, the initial retouching with the Clone tool and Healing Brush is a little unrealistic, as the skin textures look too perfect.

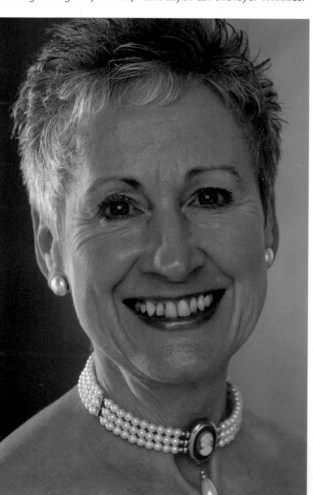

Original image
The initial portrait before retouching the wrinkles.

Step 3

Now, using the slider at the top of the Layers palette, slowly fade back the Opacity of the 'Wrinkles' layer to around 50–75%. This will gradually reveal the original, untouched background layer beneath, achieving the effect that you (or your subject) are after. This gives you the ability to turn back the clock, making your sitter look younger and producing a wonderful, natural-looking skin that will flatter any subject. If you now toggle the layer on and off, using the eye icon in the Layers palette, you'll see the full extent of this digital trickery.

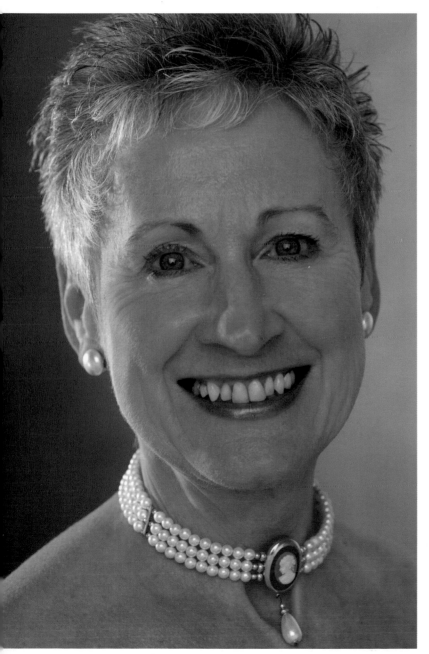

Final image after retouching

With the Opacity of the 'Wrinkles' layer reduced to 60%, Angela is instantly cast in a more flattering light.

Layers

Try to imagine layers as being like stacked, transparent sheets of glass on which you can make non-permanent changes without affecting the integrity of the original picture (the background layer). You can apply numerous special effects to these layers including digital filters, colour, contrast and brightness corrections, cloning and healing. All of these effects and changes can be switched on and off when you click on the little eye icon adjacent to each layer in the Layers palette.

TECHNIQUE 3:
REDUCE RED EYE

Red eye is the very unattractive side effect – quite commonly seen in amateur photographs – that is caused when your on-camera flash is too close to the lens axis. When the flash goes off, the light enters the eye and is reflected off the back of the retina, causing an unpleasant discoloration. This often appears in photos taken at parties, when on-camera flash is generally used. The good news is that this effect can be fixed in a number of different ways, both before and after the photograph has been taken.

In-camera red-eye reduction techniques

When using flash, try to ensure that it is as far away from the centre of the lens axis as possible, so that the light will not be able to enter your subject's eyes directly. This means positioning your flash off-camera. In reality this is not always possible or practical, especially when the flash is built-in. If this is the case, try using your camera's Red Eye Reduction mode. Red eye is most common in a darkened room when your subject's pupils are fully dilated to try to gather as much light in to the eye as possible. Many cameras produce a quick burst of flash to shrink the size of the pupil and then follow this with a second flash for the actual exposure. However, while helpful, this method is not always successful and so the problem must be fixed in post-production instead.

Step 1

Zoom in to your subject's eye area at 100% magnification to clearly see what you are doing. Select the Red Eye tool and click on the eye with the crosshair. The red eye is instantly removed and the pupil is put back to its original colour. Now do the same with the other eye.

Original image
The initial portrait before any red-eye reduction. The shot has the harsh feel of a typical on-camera flashgun. This type of set-up rarely produces flattering results, but sometimes on-camera flash is more convenient or is the only option you have at your disposal.

Screengrab of the Red Eye tool at work
One eye has been completely restored. The tool is very intuitive, so you don't even need to be completely accurate with where you place the crosshair.

Final image

The finished result looks almost like a new photo and with minimum effort. Jemima's unpleasant red eyes have been completely replaced and the image is now far more appealing.

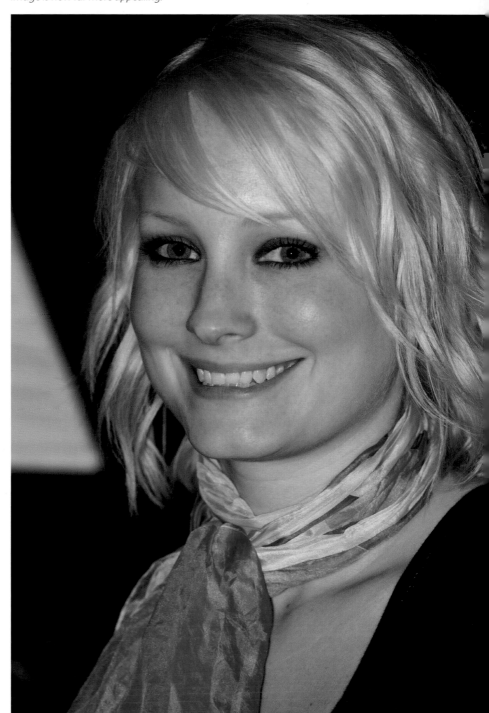

Red-eye elimination in Photoshop

Like many Photoshop techniques, there are several different ways of getting rid of red eye in your images. With older versions of the software, this effect can still be achieved, but the method is slightly more difficult and takes a little longer. However, since the introduction of the Red Eye tool in Photoshop CS2, and recent versions of Elements, things have become far easier.

The Red Eye tool is very simple to use and can be found as the fourth option in the drop-down menu of the Healing Brush. This is the quickest and most effective way to cope with red eye in the digital darkroom and simply requires you to select the tool and click on the pupil to dramatically reduce the red colour. You can also experiment with two options; Pupil Size, which increases or decreases the size of the area that is corrected, and Darken Amount, which adjusts the strength of the effect.

TECHNIQUE 4:
TONE YOUR BLACK AND WHITE IMAGES

One of the great things about digital photography is that you can shoot your images in colour and then convert them into black and white. As with many techniques in Photoshop, there are a number of ways to achieve this effect, including converting the image from RGB to Grayscale (Image > Mode > Grayscale) or desaturating the colour image (Image > Adjustments > Desaturate). Both these techniques work fine in older versions of Photoshop, but in CS3 there is a better way using the Image > Adjust > Black & White function. This very flexible new option even allows you to create a Black & White adjustment layer so the adjustments are totally non-destructive to the original image and can easily be changed or toggled on and off. Whichever way you create your mono image, toning it with a traditional sepia or contemporary blue tone is then just a few clicks away.

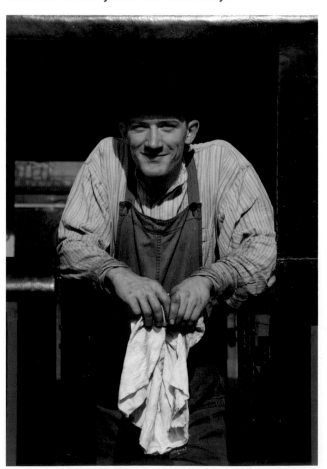

Step 1

First, create a new Black & White adjustment layer by clicking Layer > New Adjustment Layer > Black & White. Leave the layer name as 'Black & White 1' and click OK.

The dialog box that comes up allows you to make numerous subtle tonal changes to your image. You can fine-tune the tonal values of the colours in the original colour file via the sliders. For example, by selecting Reds and sliding the pointer to the right you will make the red parts of the original image lighter and by sliding to the left, you make these tones darker. The same applies to the other colour sliders.

Another opportunity that you have with this dialog box is to select one of the ten standard preset values. These will apply pre-defined tonal values to your image in a very similar way to how a traditional coloured filter would have affected a roll of black and white film. I liked the effect that the Green preset had on the values of this particular image, so I set that and the tonal changes were applied.

You now have the option of tinting the image with a colour that would be appealing to this type of subject. You can easily check the Tint option and apply Hue and Saturation adjustments to the image. However, this new dialog can be a little limiting, so instead click OK and then tone the image using the more familiar Color Balance dialog.

Screengrab of the Black & White dialog in Photoshop CS3
The level of control offered by this new function allows you to make advanced changes to your monochrome image via the colour sliders.

The original colour image
First choose an image to convert to black and white and open this in Photoshop.

Step 2

Next create a Color Balance adjustment layer to add the toning effect by clicking Layer > New Adjustment Layer > Color Balance. With this particular dialog, you can choose to add a range of colours to the image. This could be a cooler tone by moving the Blue slider to the right, or in this case, a warmer sepia tone by moving the Yellow and Red sliders. For this image I dialled in values of +7 for Red and –5 for Yellow, leaving the Midtones Tone Balance checked. This option allows you to effectively 'split tone' the highlights, midtones and shadows in the digital image in a similar way to how this would have been done in a traditional darkroom with a choice of paper, developer and chemical toner. I also chose to add a little colour to the shadow areas by clicking the Shadows option and dialling in +2 for Red and –5 for Yellow.

Screengrab of the Color Balance dialog

A Color Balance adjustment layer can be used to add a range of toning effects, depending on what will suit the image best.

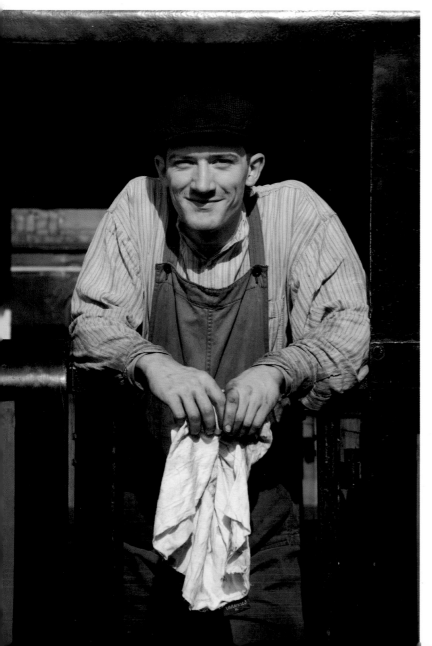

Adjustment layers

Adjustment layers are very useful tools to use when manipulating your digital images, as you can conveniently make colour and tonal changes without affecting the pixel values of the original file. To open up a whole host of adjustment layer options click Layer > New Adjustment Layer and then choose your preferred dialog. These adjustments can be changed time after time and will never damage the integrity of your original file. The down side is that adjustment layers do increase the image file size but, in my opinion, their advantages far outweigh the drawbacks.

The final sepia split-toned black and white image

A few clicks are all it takes, and Aaron is now in sepia shades – a far easier, quicker and much less smelly method than the traditional wet darkroom technique.

TECHNIQUE 5:
DODGE AND BURN
FOR CREATIVE EFFECT

Dodging and burning are traditional darkroom techniques that have now been introduced into the digital darkroom. Dodging refers to lightening, and burning to darkening specific parts of the image. These used to be somewhat hit-and-miss techniques. However, with the digital tools, you can even choose which tones of the image are affected – the highlights, midtones or shadows – allowing you tremendous creative control. By choosing an appropriate brush size (which defines the area to be dodged/burned) and by setting the exposure percentage (strength of effect), you will be opening up a world of possibilities.

Step 1

The original image was scanned from a black and white negative and converted into a digital file for retouching in Photoshop. First, clean up any minor blemishes on the image with the Clone and Healing Brush tools (see Technique 1). As it's always a good idea to work on image alterations on a separate layer, duplicate the background layer and call the new layer 'Dodge/Burn'.

Step 2

Using a large diameter brush (the actual size will depend upon the resolution of your image), carefully burn in areas of shadow and then midtones to add a darker tone and depth to the image. Here, this included work on the scarf, hat and eyebrows, with a smaller brush used for the eyelashes. This all helps to concentrate the viewer's attention on the subject's face.

Screengrab of the Burn tool in action
Careful burning in of the shadows and midtones adds depth and drama to the image, making the pale tones of the subject's face stand out more.

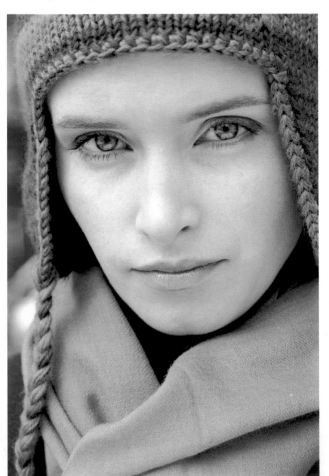

Retouched image ready for dodging and burning
The original scan was cleaned up and then duplicated on to a new layer ready for the dodging and burning techniques to be applied.

Step 3

Using a small diameter brush, the Dodge tool set to a small Exposure of around 5% and Shadows selected in the Range menu, carefully work on lightening various areas of the image. Here, this included the shadows on the face and the dark shadows beneath the eyes. Finally, switch the Range menu to Highlights and dodge the model's eyes to clean them up and make them more vibrant.

Screengrab of the Dodge tool in action

Set a low Exposure of around 5–10%, as this will give you the opportunity to build up the effect, rather than trying to achieve the required result in just one or two strokes at a higher exposure.

Image suitability

You will find that the Dodge and Burn tools are more useful when working on black and white images. With colour files, extreme use of these tools may introduce a cast that will look unrealistic in the final print. To some extent, this can be reduced with the Sponge tool, which is located under the same menu.

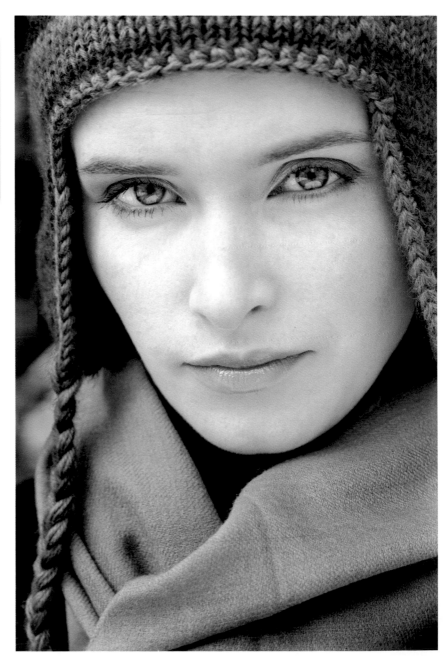

Final image after dodging and burning

The final image of Rachel shows the subtle effect of dodging and burning selected areas for maximum impact. Notice the small but irritating highlight area on the far left of the image that was also burnt in. The end result is punchier and far more dramatic than the original.

TECHNIQUE 6:
ADD SOFT FOCUS AND BLUR

Soft-focus filters were traditionally used in front of the camera lens to create wonderfully atmospheric photographs with glowing highlights and an unmistakable dreamy feel. Using different makes and strengths of filters, selecting different lens apertures and choosing different focal lengths, the results could be varied to produce the effect you wanted. The only problem was that the final result could not be seen until the film came back from the lab and if it wasn't quite right, all you could do was re-shoot. However, with the aid of Photoshop layers, filters and blending, you can now produce a similar soft-focus effect that can be adjusted with perfect precision.

Original image
The initial portrait without any soft focus applied in Photoshop. The soft tones of the model's skin and faraway look in her eyes will work well with the ethereal soft-focus effect.

Step 1

Not every image will benefit from the soft-focus effect, so choose your picture carefully, ensuring you will actually be enhancing it. Try to choose a picture that already has blurred elements caused by shallow depth of field, and something with a romantic quality that will be brought out further by the use of soft blurring.

Step 2

Duplicate the background layer to make an identical layer. Call this 'Gaussian Blur Layer'. Apply the Gaussian Blur filter found under Filter > Blur > Gaussian Blur. The pixel radius will depend on the image resolution, but for an A4 (29.7 x 21cm/11¾ x 8¼in) photo at 300dpi, try setting it to around 50. The image will look very out of focus, but don't worry – you will fix this in Step 3.

Step 3

It's always nice to have the eyes and mouth largely in focus on most photographs, so the next action is to use the Eraser tool to erase these areas of the blurred layer, revealing the original sharp background layer underneath. Use a reasonably large, soft brush with an Opacity of around 25% so you can gradually build up the in-focus effect.

Screengrab of image with Gaussian Blur applied
As you can see, this has blurred the entire image, but the effect will be brought under control in the next step.

Screengrab of image during erasing
Erasing the blurred layer on top reveals the in-focus layer beneath. Using a soft brush on a low Opacity allows you to gradually bring back the focus to the areas that you want.

Step 4

Now duplicate the Gaussian Blur Layer to produce an identical layer. Name this the 'Soft Light Layer'. Next, apply a Soft Light Blending Mode to increase the contrast and help create that typical glowing highlight effect. The Blending Mode options are located in the drop-down menu in the Layers palette. You might like to try some of the other modes such as Overlay and Hard Light, but personally I find these a little too coarse.

Screengrab of image with Soft Light Blending Mode
Blending Modes remain something of an enigma to most photographers, but the key to their use is experimentation. They can be used on your layered images for various creative effects such as lightening, darkening, adding contrast and even changing colour and tone.

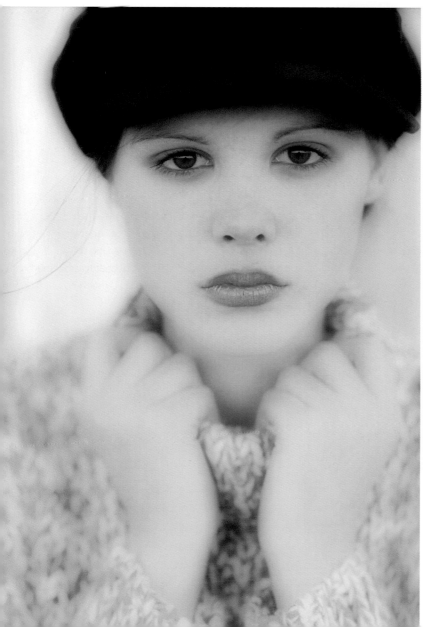

Final image with the digital soft-focus effect applied
Here, I've set the Opacity on both the edited layers to around 50%, but you can move the Opacity slider back and forth to see which setting suits your particular shot best. Faye now has a wonderfully wistful and starry-eyed appeal. The eyes are still relatively sharp, but the rest of the photo has glowing highlights and soft tones.

TECHNIQUE 7:
CREATE A HIGH-KEY VIGNETTE

Old-style vignettes or soft-fade effects have long been a popular technique for portrait photographers. Traditionally, the vignette is an oval shape that burns out to pure white, concentrating the viewer's attention on the subject and eliminating much of the background. It's an easy technique to master and can create a romantic or period feel to your people photos.

Step 1

The original image of this pilot in his Spitfire is somewhat ruined by the fact that the background hanger is so modern. As it was too tricky to replace the whole background, I decided to fade it out to create a high-key vignette that would also be in keeping with the old-fashioned subject matter.

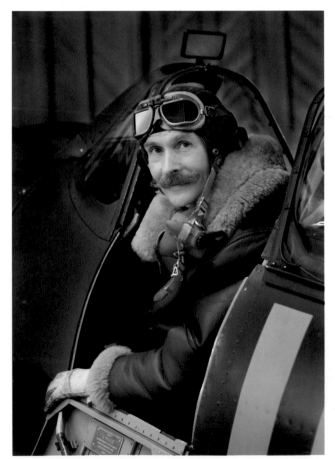

Original image
The initial portrait – a timeless subject that is spoiled by a present-day background.

Step 2

First, make an oval selection around the subject using the Elliptical Marquee tool. Click your mouse on the top left of the subject and drag down towards bottom right to create this selection. If you are not entirely happy with the placement, just drag the selection to a better position.

Screengrab of the oval selection
Use the Elliptical Marquee tool to create an oval selection from which to fade out.

Step 3

Next, soften the edge of the selection using the Feather option. Go to Select > Modify > Feather and choose a radius of around 250 pixels for an A4 (29.7 x 21cm/11¾ x 8¼in) image at 300dpi. Larger images may need further feathering, but this is very much dependent upon personal preference.

Screengrab of the Feather dialog
Feathering the edges of the selection will give you a soft edge so that the fade is gradual.

Selections

Perfecting selections is a key part of mastering the art of digital image manipulation. By being able to accurately select areas in an image, it's then possible to apply all the various techniques and operations that make Photoshop such an incredibly flexible and useful modern photographic tool. There are numerous ways to make these selections, from the simple Marquee tools to more advanced methods such as the Extract Tool and Quick Mask. A little time practising and experimenting with these basic techniques will stand you in good stead to achieving professional results.

Step 4

Now invert the selection to select everything except the subject by clicking Select > Inverse. Finally, erase the background area by hitting the Delete key, deselect the Marquee and the vignette effect is complete.

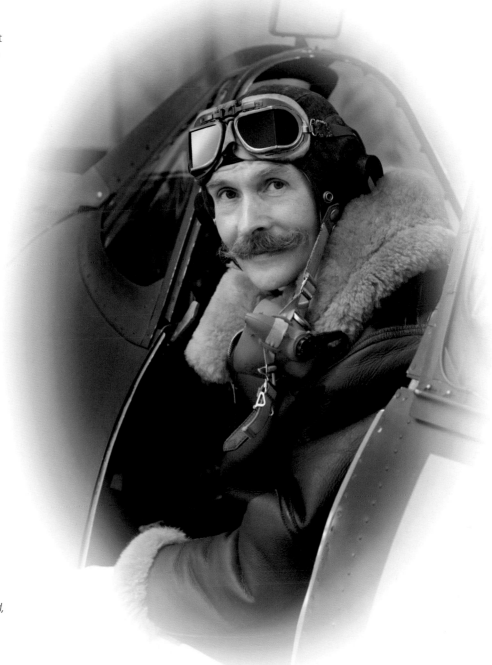

Final image
The use of a soft vignette has removed the unsightly background, making this a portrait of Charlie that could easily have been taken during the golden age of flight.

TECHNIQUE 8:
LIGHTEN EYES AND TEETH

One of the most common digital techniques that photographic studios employ is whitening their subject's eyes and teeth. You can see this effect on the covers of most glossy magazines, where the model or celebrity has that perfect Hollywood smile and their eyes look fresh and vibrant. At the simplest level, the whites of the eyes and teeth can be lightened with the Dodge tool set to a low Exposure. However, to create truly professional images, try this more precise technique. It involves the Magic Wand tool, Quick Mask mode and a Curves adjustment layer to modify the contrast and brightness.

The Magic Wand

This tool is great for making fast selections in areas of similar colour such as teeth and eyes. You can specify the Tolerance to select pixels based upon their similarity of tone. Dialling in a low Tolerance value will select only those colours that are very close to the initial pixels you click on, whereas a higher value will select a wider range of colours. There are also a few more advanced options relating to the Magic Wand. These include Anti-Aliased, which creates a smoother-edged selection; Contiguous, which selects the same colours in the adjacent areas only (opposed to the entire image); and Sample All Layers, which selects colours from all the visible layers in a multi-layered image, rather than just the active layer.

Quick Mask

This is a very simple way of modifying an initial selection while working on an image. Once in this mode, the mask can be added to or subtracted from by simply painting over the red 'Rubylith' mask with one of the Brush tools. Pressing the 'X' key, you can toggle between painting in the mask (using black as foreground colour) to painting out areas of the mask (using white as foreground colour). You can also control the feathering of the edge of the selection by varying the softness of your brush. Once you are happy with the selection, press the 'Q' key to exit Quick Mask mode and you will see the modified selection highlighted by the standard 'marching ants'. This area is now selected and precise adjustments can be made without affecting other areas of your image.

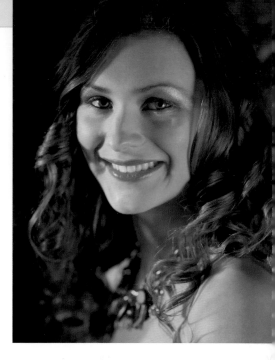

Original image
The unedited image is fine, but the model's eyes could benefit from a few Photoshop eye drops and her teeth from a quick trip to the digital dentist.

Step 1

Zoom in to the image at 100–200% magnification, select the Magic Wand tool and click on the teeth. All the pixels of a similar colour will now be selected. The selection will not be perfect, but don't worry about this, as you will now use a Quick Mask to refine the selection.

Screengrab of the Magic Wand tool selecting pixels
When using the Magic Wand tool, you can add to the selection by holding down the Shift key. Modify the Tolerance setting until you achieve a rough selection that you are happy with.

Step 2

Press the 'Q' key to enter Quick Mask mode. This will change the image to a red colour, indicating the masked areas. By using the Brush tool with black set as the foreground colour, you can now paint in the mask area or, by switching the foreground colour to white, paint it out – use the 'X' key to switch between the colours quickly. When happy with the mask, click the 'Q' key again to exit the mode. You should now have a perfect selection that will be used as the basis for an adjustment layer.

Screengrab of the Quick Mask
When creating the mask, use a soft-edged brush to feather the selection somewhat, painting right up to the edge of the teeth. The same applies to any mask you make to lighten the eyes.

Step 3

Make a Curves adjustment layer to lighten the selected area more accurately. Click Layer > New Adjustment Layer > Curves and name this layer either Eyes or Teeth depending on which area you are working on, then click OK. Now you can lighten the selection by moving the central section of the curve slightly towards the top left of the graph, which has the effect of brightening up the whites. When you are happy with the result, click OK.

Screengrab of the Curves adjustment layer dialog
You could just use the Dodge tool to lighten the selected area, but a Curves adjustment layer gives you more control over the effect, allowing you to create the perfect pearly white smile.

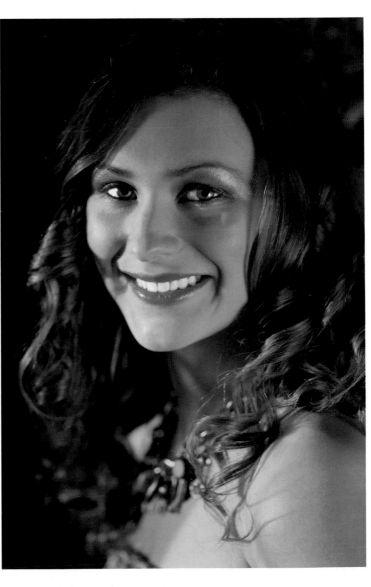

Final image
In the finished portrait, the whites of Emily's eyes have been lightened in exactly the same way as her teeth. The end result is only subtly different from the original, but gives an added touch of sparkle that helps lift the image.

TECHNIQUE 9:
CREATE A CROSS-PROCESSED EFFECT

Cross processing refers to a traditional darkroom developing method that changes the appearance of normal film to produce high-contrast images with wild colours and a wacky look. When it was first discovered in the 1980s, it gave such an unusual effect that it became a favourite technique among fashion and rock photographers. It was, however, tricky to master, required a certain degree of experimentation and you could never be quite sure whether it would work or not. All this has changed with digital imaging, as the effect can now easily be reproduced with far more control and without all the hassle. It is based upon the Curves dialog, which controls the colour, contrast and tones, and once mastered will help you to create some eye-catching images that will really enhance certain types of portraits.

Step 1

First create a Curves adjustment layer with Layer > New Adjustment Layer > Curves, call this 'Cross Process' and click OK to bring up the Curves dialog box. In Photoshop CS3, the Curves dialog has had a revamp and now has a few more options than previous versions. You'll notice that it now has a Presets drop-down menu, which offers several standard settings for common special effects and includes a Cross Process option. By all means give this a try, but I find it a little unpredictable and I still like to tweak the individual Red, Green and Blue channels to obtain the precise effect I am after.

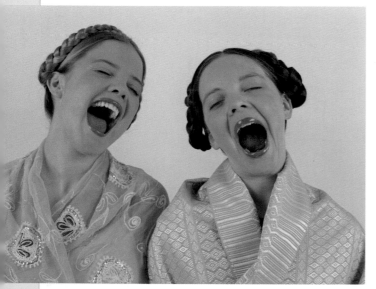

Original image
The initial portrait is a little flat contrast-wise and would benefit from the dramatic cross-processing effect to bring it to life.

Screengrab of the Curves dialog
CS3 now offers preset Curves options, including Cross Process, but it may not offer the exact result you are after for your particular image, so some manual tweaking may still be required.

Step 2

In the Curves dialog, the tonal range of the image is represented by a straight diagonal RGB baseline that runs from the shadow areas at the bottom left to the highlight areas on top right. By forming this line into an 'S' shape, it's possible to increase the contrast to add a little more punch to the image. It's also possible to tweak the individual Red, Green and Blue channels to affect just these colours in the image by selecting them in the Channel drop-down menu. By deviating further away from the original straight diagonal line, you will get stronger colours, higher contrast and richer saturation. It will require some experimentation to produce the effect you desire. If you do get into a muddle, just bring up the Reset button by pressing Alt (Mac) or Control (PC).

Screengrab of the adjusted curve

Adjusting the curve of the different colour channels in turn allows you to create precisely the desired effect.

Step 3

By also pulling the Blue channel line down towards to the bottom right, I've introduced a slight yellow colour cast, which is an inherent characteristic of a traditional C41 to E6 cross-processed film image. I also chose to crop the image a little for more impact.

Final cross-processed image

The completed portrait of Charlotte and Rebecca shows an increase in contrast, which cleans up the whites and produces darker shadow areas, creating a much more vibrant image than the original.

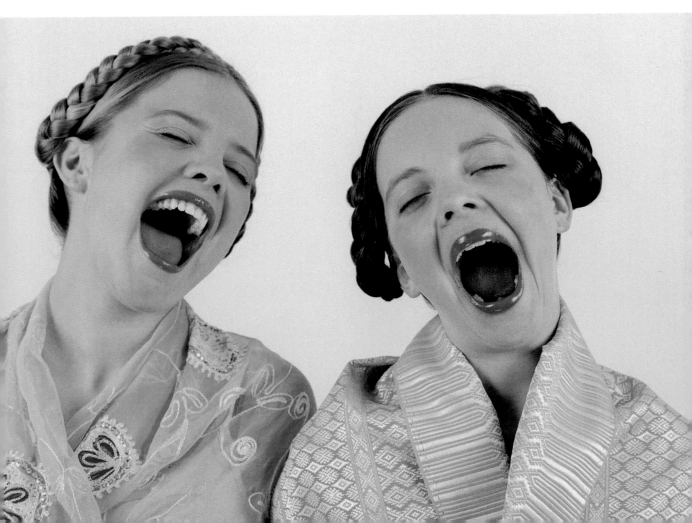

TECHNIQUE 10: TRY THE DIGITAL DIET

As a portrait photographer, it has always been your job to flatter and enhance the appearance of your subject. Until recently, these skills have been somewhat limited to the careful choice of angle, lens and light, but it's now possible to alter the physical appearance of your subject using the Transform functions in Photoshop. These techniques are quite simple to master and allow you to change the shape, size, length and form of your subject – making it possible to go on the 'digital diet' and shed a few pounds without all the hard work. While this technique cannot work miracles, it will allow you to make subtle enhancements to your images that your subjects will greatly appreciate.

Transform tools

The Transform features in Photoshop will allow you to alter, scale, rotate, skew, distort perspective and warp your images. Each command has its own characteristics and requires some experimentation to fully understand its capabilities. In order to use the Transform functions, you will first need to select the area you wish to alter, such as the nose, the ears, eyes, mouth or even the whole image. Use the various Selections tools for this and then apply the Transform functions to achieve the alterations you want. In the example here I've shown you how to slim a subject down slightly, but the same technique can be used to change any other part of the body to stretch, squash, squeeze or even enlarge!

Step 1

This shot of Eva beneath a Caribbean palm tree is very successful already, but she could benefit from a little Photoshop trickery to achieve that perfect 'Barbie Doll' figure.

Step 2

First make a selection around the area you wish to work on using the Lasso tool. In this case, I've selected the little 'love handles' just above the model's right hand. The selection does not have to be absolutely exact, but only select the area that you want to alter – so in this case not her finger.

Screengrab showing the area to transform being selected
The Lasso tool offers the most flexibility of all the Selection tools to let you select the exact area that you wish to transform.

Original image before transforming
Eva has a great figure, but the very slight bulges at her hips could be reduced to streamline her further.

Step 3

Next, select the Warp function from the Transform menu by clicking Edit > Transform > Warp. This will place a grid over the selection and by pulling upon the lines of this grid, you will be able to alter the shape and contours of the selection. Don't be worried about the empty, white areas that are left behind as you can clone these back in later. Now hit Return to activate the command, and deselect.

Screengrab after applying the Warp
The Warp function has changed the curves of the body and has created a more pleasing shape.

Step 4

Repeat the previous three steps for the other side of her figure. Again, select the area with the Lasso tool, then click Edit > Transform > Warp until you achieve the desired result you are after, then hit Return and deselect. Once again, you will clean up with the Clone and Healing Brush tools in a moment, so don't worry about the white area and any small strips of skin tone left behind.

Final image after the digital diet
Just a few clicks and Eva now has a dream figure to match the dream location, and you would never know that the effect had been applied.

Step 5

Now all you need to do is clone in the blank areas and any other stray pixels with the Clone and Healing Brush tools learnt in Technique 1 and the transformation is complete.

Screengrab after cloning and healing
The Clone and Healing Brush tools have been used to clean up the image to create a seamless finish.

ACKNOWLEDGMENTS

There have been so many people involved in the production of this book that it's difficult to mention everyone, so many thanks to you all.

However, I'd particularly like to thank everyone at David & Charles for taking such an interest in my work and to Ame, Neil and Sarah for their many hours of editing and advice.

A big thank you must also go to Visit Britain, however, I'd especially like to express my gratitude to Jasmine and her diligent team at www.britainonview.com, who've worked with me to produce several of the commissioned images in this book.

I'd also like to thank all those who have appeared in this book as models and those who have helped me with styling, art direction and make-up, including Natasha Freeman (www.natashafreeman.co.uk), Jemima Chatfield (www.jemimachatfield.co.uk), and the model agency Sandra Reynolds (www.sandrareynolds.co.uk).

Thanks must also go to Gary at Lastolite (www.lastolite.com) for his faith, help and advice on their great products, Hardy at Flaghead Photographic (www.flaghead.co.uk) for supplying his RingFlash adaptor and Sam at Viewfinder Photography (www.viewfinderphotography.co.uk) for help with his great new portable flashgun accessories.

And last, but by no means least, I'd like to thank Chris at The Flash Centre (www.theflashcentre.co.uk) for his buying advice and unbeatable after-sales service with my Elinchrom flash equipment and accessories – without which some of these images would undoubtably have looked somewhat underexposed!

ABOUT THE AUTHOR

Rod Edwards is one of the UK's leading photographers, specializing in people and places imagery for the publishing, advertising, design and corporate areas of the photographic industry. His client list includes *The Sunday Times*, *The Sunday Express*, *The Observer*, *The Independent*, *The Mirror*, *The Guardian*, Visit Britain, Ordnance Survey, The AA, The RNLI, Reader's Digest, Sainsbury's, HSBC, Saab, Texaco, Shell Oil, Fuji Film and Kodak.

Rod markets his images both from his studio in East Anglia and through international photographic agencies including Getty Images, Alamy, the National Trust Photographic Library and Britain On View. He has photographed many fascinating subjects around the world, including a personal portrait sitting with HM The Queen and The Duke of Edinburgh for the Sandringham House Golden Jubilee Guide.

He is a member of the Association of Photographers in London and a regular contributor to the UK photographic press, including *Practical Photography*, *Photography Monthly*, *Digital Photographer* and *Professional Photographer* magazines.

For more information and further examples of Rod's work, visit www.rodedwards.com and www.rodedwards.co.uk.